CIRENCESTER AT WAR

PETER GRACE

AMBERLEY

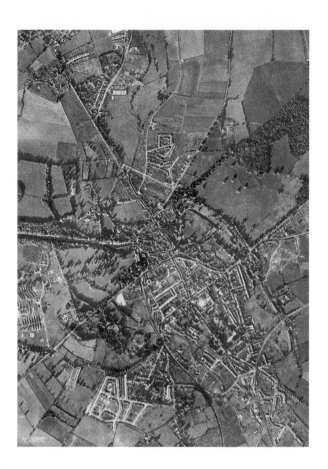

First published 2017

Amberley Publishing
The Hill, Stroud
Gloucestershire, GL5 4EP

www.amberley-books.com

British Library Cataloguing in Publication Data.

A catalogue record for this book is available from the British Library.

ISBN 978 1 4456 6870 3 (print)
ISBN 978 1 4456 6871 0 (ebook)

Origination by Amberley Publishing.
Printed in the UK.

Contents

Introduction

For years Cirencester has been known as the Capital of the Cotswolds, having all the hallmarks of a market town, with an urban concentration surrounded by expanses of peaceful rural hinterland dotted with smaller settlements. Today it is not a place readily associated with military activity, yet the town itself owes its origins to the Romans, one of the greatest military powers the world has ever known. In order to conquer and control Britain, an extensive network of roads was built throughout the land by and for the military. In the first half of the first century AD, the Fosse Way ran from Lincoln to Exeter, forming a temporary border between occupied and unoccupied lands. Where it crossed the River Churn, two Roman forts were built and the local Dobunni tribe gravitated from their Bagendon settlement to trade with the Romans. Eventually Corinium Dobunnorum was established. It became the second largest settlement in Roman Britain and the civic and trading centre for this corner of the Roman Empire.

Throughout the centuries, Cirencester has never been far from conflict. In Saxon times it stood in the unstable border lands between Wessex and Mercia. Following his defeat by King Alfred in 878 at Ethandune, the Danish King Guthrum was converted to Christianity and lived for a period in Cirencester. Cirencester's castle was burned down by Stephen's forces during the civil war between Stephen and Matilda in AD 1141. During the Wars of the Roses, the earls of Kent and Salisbury, in rebellion against Henry IV, while trying to restore Richard II to the throne, were captured then executed in Cirencester Market Place. Their forces set fire to some buildings as a diversion and in Shakespeare's play *Richard II*, a character announces, 'The rebels have consumed with fire our town of Cicester in Gloucestershire' (Act V, scene vi). It may be from this attempt to maintain the poetic metre that a version of Cirencester's name came into being, one maintained in the past as an affectation by those aspiring to certain higher levels in society. It is also claimed that the treasure chest taken from the two executed prisoners was used to finance the construction of the magnificent tower of Cirencester's parish church.

The Market Place was again the witness of violence, for what is seen by many to be the first action of the Civil War. In August 1642 Lord Chandos, the king's deputy-lieutenant for Gloucestershire, came to town to raise support for Charles I by trying to execute the Commission of Array. The town had sided with Parliament and a mob turned on his lordship. He was rescued by the retainers of the Poole and Master families, who owned the town's two great estates, but his coach was hacked

to pieces outside the Ram Inn. Within a year, Prince Rupert's forces took the town for the king after seven hours of heavy fighting, and several hundred prisoners were held in the parish church without food or water and then marched to Oxford in freezing conditions. The king visited in August 1643, staying with the Master family in the Abbey House. But a month later the Earl of Essex surprised the Royalist garrison on a moonless night and retrieved the town for Parliament. The next and last time troops fought in the streets of Cirencester was during the Glorious Revolution when the Duke of Beaufort, in support of James II, sent troops to Cirencester to intercept forces loyal to William of Orange. During the fighting Lord Lovelace, the leader of William's supporters, was captured, but the Duke's Captain Lorenge and his son were killed.

In 1803, at a time of international crisis, forces were raised in the form of a local militia by Earl Bathurst when hostilities resumed against France. In 1881, the Royal North Gloucester Militia, first raised in 1757, became the 4th Battalion in the Gloucestershire Regiment. They were billeted with the town's people in Cirencester from 1854 until 1856. From 1859 they assembled in town each year for training, but were housed in the Cecily Hill Barracks built in 1856. The 4th Battalion of the Gloucestershire Regiment was to see action in the Boer War, leaving town via the GWR station in Tetbury Road.

During the First World War the town played host to hundreds of service personnel, notably the South Wales Borderers, 10th Gordon Highlanders and the 7th Cameron Highlanders, who were billeted in private homes or halls such as the Corn Hall in the Market Place, the Temperance Hall in Thomas Street and Apsley Hall in Sheep Street. In addition, a battalion of the Gloucestershire Yeomanry were encamped in Cirencester Park. Bingham Hall was requisitioned as a military hospital treating over 400 patients in its first year and over 1,850 by the end of the war. The hospital was well served by the Watermoor Station on the Midland & South Western Junction Railway running from Southampton to Cheltenham. The casualties were brought in from the disembarkation ports and Tidworth Military Hospital. The war left a legacy. Apsley Hall in Sheep Street was taken over by the cottage hospital. X-ray equipment was relocated from the Bingham Hall Hospital when hostilities ceased. With the addition of inscriptions and rolls of honour to the façade of the Apsley Hall, the hospital complex became known as the Cirencester Memorial Hospital, serving the town as its main hospital until the late 1980s. The other legacy of that war is summed up by the two rolls of honour, on the former hospital and the memorial in the Market Place. Over 200 citizens of Cirencester and District lost their lives in the 'Great War to end all wars', and many others were injured, maimed or affected in some way by the carnage.

Despite the alternative grandiose title given to the First World War, in 1939 the world all too soon found itself at war again. It is to this war we turn in this book, telling as much of the story of Cirencester as possible with the aid of photographs and other illustrations. The austerity and censorship prevailing at the time meant that there was a limit to photographic activity and some of the sources are, as a result, of limited quality, but every effort has been made to obtain a quality to illustrate the place, time and the people to the best advantage.

The Second World War had a greater effect on this part of the country than any other military activity since the Romans. By the term Cirencester we have, by definition, to use that wider meaning to take in the town and its hinterland, as the two are inseparable. By the end of the war there were over thirty military establishments within 12 miles of Cirencester and we therefore include illustrations and information to encompass this, along with all those everyday aspects of civilian life experienced by the indigenous population and the many thousands of strangers who found themselves in the Cotswolds and its capital in those momentous days.

Chapter 1
Wars and Rumours of Wars

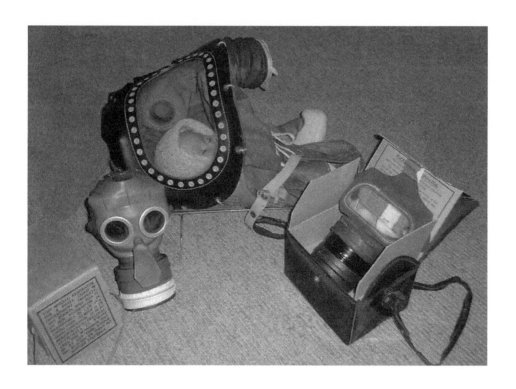

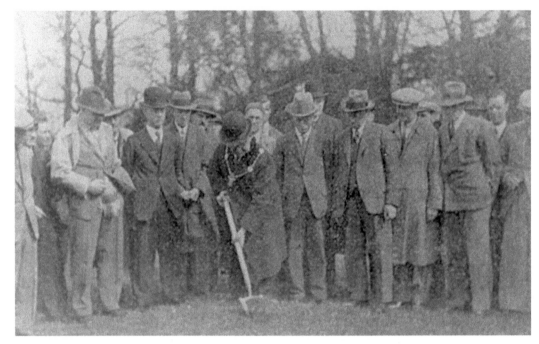

Councillor A. J. Matthews Cutting the First Sod for the Building of Chesterton Estate, April 1938

Cirencester in the early 1930s seemed a world away from mainland Europe. Life had not been easy for many in the depression of the 1920s; public works schemes such as the building of Abbey Way and Kingsmead were used to create employment. There were, however, signs of improvement. For those in the right set, the annual round of social gatherings continued as normal. Farther down the social scale the Cirencester Urban and Rural District Councils improved the provision of social housing and basic services.

"Unwanted," said the Gestapo

An artist's impression of the arrival of the Rhön Bruderhof members in Holland printed in the Dutch newspaper *De Telegraaf*, April 25, 1937.

Cartoon from the Dutch Newspaper *De Telegraf* showing the Second Wave of Bruderhof Expelled from the Rhön Bruderhof in Germany on Their Way to England

Political forces of a far more sinister nature were taking power in Germany. In 1936 Cirencester's first contact with victims of Nazism came when a considerable number of refugees arrived in the neighbourhood. The Bruderhof (brotherhood) were asylum seekers of mostly German origin. They were pacifist, fundamentalist Christians, whose creed was based on Christ's Sermon on the Mount, and they held all possessions in common. This cartoon from the Dutch newspaper *De Telegraaf* shows members of the Bruderhof on their way to England.

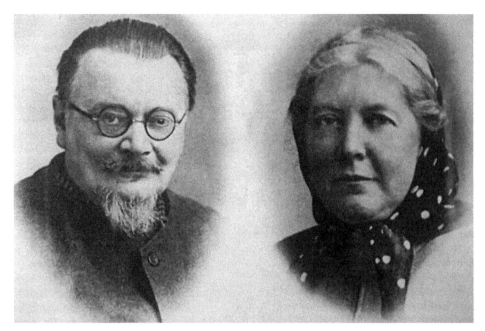

Eberhard and Emmy Arnold, Founders of the Bruderhof

The Bruderhof was founded in the 1920s by Eberhard and Emmy Arnold. As members of the Student Christian Movement before the First World War, they formed a commune with friends at Sannertz in the Fulda Valley. They based their activities on the Christian beliefs of Count Zinzendorf and Jakob Hutter, two of the leaders of the Reformation. Their education practices were taken from Pestalozzi and the practical expression of Christianity came from a friend of Eberhard's uncle, a major in the Salvation Army.

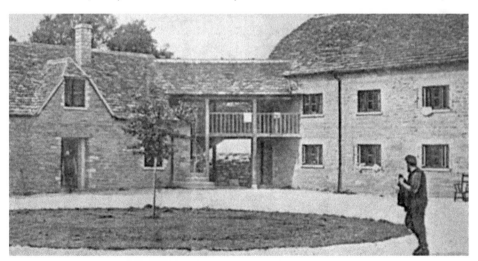

The Main Domestic Building at the Cotswold Bruderhof

This was the main domestic building in the Cotswold Bruderhof commune, which they set up at the former Ashton Field Farm, just outside Ashton Keynes, later adding Oaksey Park Farm. By 1938 they had taken in the majority of the Bruderhof members from their other communes in the Rhön, Germany, and Liechtenstein and been joined by like-minded British people, many of pacifist persuasion.

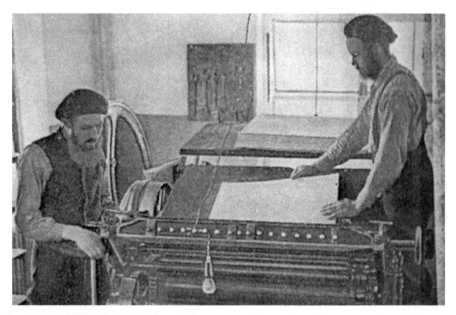

The Cotswold Bruderhof Printworks
In addition to farming, they set up a printing works and publishing house to disseminate their ideas and utilise their vast library. The library contained thousands of books, including many original manuscripts from the earliest days of the Reformation. They printed a magazine, *The Plough*, and the more mundane waxed-cardboard milk-bottle tops used on their milk rounds in and around Swindon.

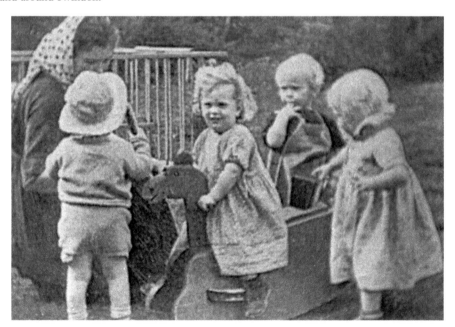

Cotswold Bruderhof Kindergarten Children
In addition to craft workshops, the Cotswold Bruderhof ran a kindergarten and school that catered for their own children, children from deprived areas of Britain and, later, young Jewish refugees. Many of the latter were trained in farming methods to be used in the settlements in Palestine.

Birmingham Salvation Army Band Visiting the Cotswold Bruderhof in 1938
The Bruderhof had strong connections with the pacifist groups in England: the Quakers supported them in many ways, including financially, and they also forged links with the Salvation Army in the area and farther afield. Despite some considerable opposition from local landowners, the government gave them support and encouragement and in 1938 they received substantial coverage in *The Times* newspaper.

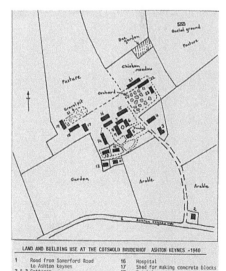

Plan of the Cotswold Bruderhof
This plan shows the layout of the Cotswold Bruderhof commune. When one of its leaders, Hans Meier, returned to Germany to deal with financial affairs, he had to report to the local Gestapo office. Before leaving he was shown a map of the west of England, with Ashton Keynes and the Cotswold Bruderhof clearly marked, and given the chilling warning: 'We know where you are.'

Standard Newspaper Photograph of the Bride and Groom

On 10 December 1938, the *Wilts and Gloucestershire Standard* published a report of a wedding in Holy Cross Church, Ashton Keynes. The bride, Baroness Von Gothenburg, and her Jewish groom, Fritz Kanitz, were guests of the Bruderhof. She was the daughter of a wealthy Austrian landowner, who sold most of his estate to pay for her to leave Austria. The wedding report omitted names and the guests were identified by profession only, to preserve their anonymity and the safety of their families in Germany after the passing of the Nuremberg Laws.

South Cerney RAF Camp

In the early 1930s most were trying to ignore the situation, remembering no doubt the First World War less than twenty years before. As late as 1937, the only substantial military presence near Cirencester, other than the Territorial Army, was RAF South Cerney, which opened as No.3 Flying Training School. Fortunately, some in Britain reading the warning signs coming from Germany and the civil war in Spain began to realise the threat to civil populations posed by the fast-developing technology of aerial warfare.

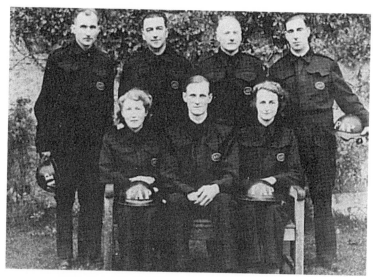

Fairford First Aid Party

The Fairford First Aid Party was one of the many set up after the government drew up the Air Raid Precautions Act in 1937 – local authorities set up ARP committees. The Cirencester and District Joint Committee, inaugurated on 19 April 1937 as Area Authority No.7, covered Tetbury Rural and Cirencester Urban and Rural District Council areas. Eventually Tetbury was given autonomy and Cirencester's two districts redesignated Authority No 6. The Cirencester councils found themselves at odds and decided that each would have its own Civil Defence Committee administering ARP, with Councillor G. Rumbol of the Urban District Council (UDC) as chairman of both.

Cirencester Municipal Offices and ARP Report Centre, Gosditch Street

The ARP Report Centre was housed in the Cirencester Municipal Offices in Gosditch Street.

By March 1938, when the basic structure was in place with separate air-raid warden systems for the two councils, the UDC provided the other ARP services. These included casualty first aid services, rescue and gas decontamination squads, Report Centre staff and messenger services with additional standby squads for the utilities, road repairs and demolition.

The Barton Hall Gloucester Street

The Barton Hall in Gloucester Street contained the offices of the Cirencester Rural District Council from where the clerk, Mr Hall, eventually took on the responsibilities of Rural Billeting Officer, overseeing food and fuel supplies similar to his counterpart at the Urban District Council.

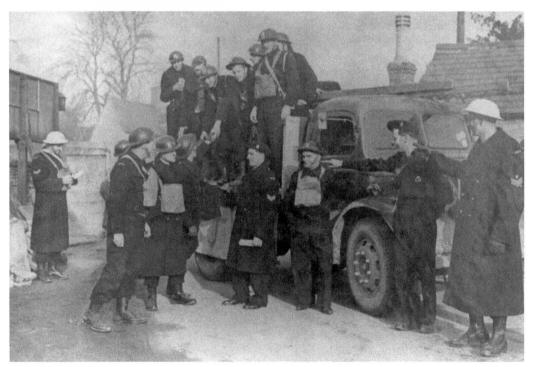

Rescue Squad, ARP Headquarters, UDC Canal Wharf Depot, Sheep Street

Along with the demolition squad, the men of the rescue squad were trained to deal with the aftermath of bombing.

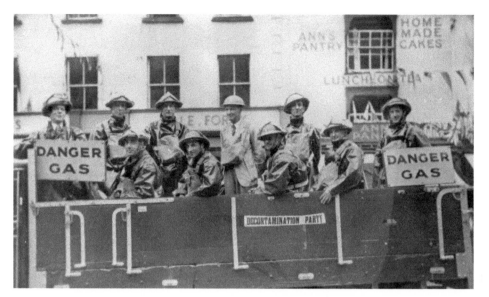

The Decontamination Squad on Parade, in the Market Place
With the threat of gas bombs being used, the decontamination squad held an important position. There was a decontamination centre set up in one of the former wharf buildings at the UDC depot and the men were trained in emergency decontamination techniques for dealing with people and property.

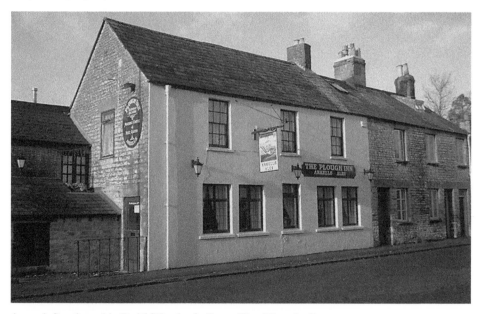

Area A Section, Air-Raid Warden's Post, The Plough, Stratton
The Plough in Stratton was used as an air-raid warden's post. Air-raid wardens were appointed under Chief Warden Colonel F. L Pardoe, and Cirencester was divided into six sections: Stratton was Section A, Bowling Green and Gloucester Street were B, Cecily Hill and Tetbury Road were C, Victoria Road and London Road were D, Watermoor was E and Chesterton was Section F. In each section two or three warden's posts were connected to the section post by runners. The section post was connected by telephone to the Report Centre in the Municipal Offices.

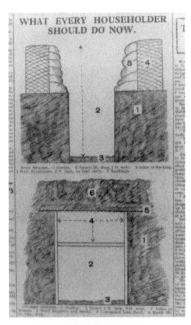

The Standard's 'Do it Yourself' Bomb Shelter

With the situation worsening in Europe, the *Wilts and Gloucestershire Standard* published instructions on how to build a bomb shelter. The Munich crisis in September 1938 led to increased ARP activity. Training exercises, some on a grand scale, took place in Cirencester Park, with simulated gas and aerial attacks by aircraft from RAF South Cerney. Anti-gas trenches were dug in Burge's field next to Mason and Gillette's bacon factory off Meadow Road, with others planned for the Bowling Green Estate.

The Siren Mounting on the Police Station Park Lane

An air-raid siren was placed on the roof of the police station in Park Lane, and this picture shows its mounting. The siren, tested on 28 September 1938, was later augmented by a siren on the Electricity Company Offices next to the Municipal Offices. This showed that if the wind was in the wrong direction, people in Watermoor were unable to hear the alarm. Initially wardens blowing whistles were tried, but after the outbreak of the war a steam whistle was installed in the chimney of Cole's Mill in Lewis Lane.

The Prime Minister at Watermoor Station

In 1938, Prime Minister Neville Chamberlain was greeted by the stationmaster, Mr Maslin, when he arrived at Cirencester's Watermoor station on his way to a few days' rest with friends at South Cerney. This was just after many had breathed a sigh of relief when the prime minister declared, 'Peace in our time!' on his return to Heston from negotiating with Hitler in Munich.

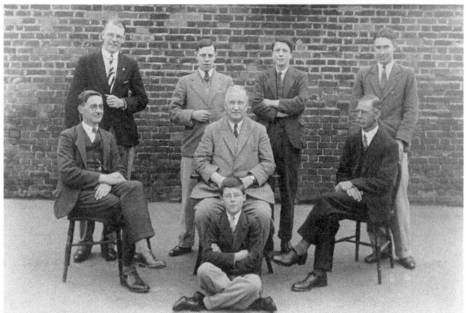

Taffy Evans, Clerk to the Area 6 ARP Committee, with Other Members of the Council School Staff

The Munich promise was short-lived, and with 1939 came ominous warnings of imminent war. With flagging optimism the authorities redoubled their ARP efforts. 'Taffy' Evans, a teacher at the Council School, Lewis Lane (seated on the far left with other members of the school staff), and clerk to the Area 6 ARP committee, did much to organise the practical side of things. Following the experience of the First World War, the fear of gas worried most people and steps were taken to combat the threat. The urban and rural populations had been measured for gas masks at the time of Munich and around 30,000 gas masks were ordered for ARP Area 6.

The Old Bathurst Museum, Tetbury Road

In 1939 the vacant Old Bathurst Museum in Tetbury Road was used for assembling the gas masks. The components – face mask, filter and carefully designed cardboard carrying-case – arrived in Cirencester in August, and the initial task of assembling 27,000 masks took local volunteers ten days, working four-hour shifts around the clock. The new Corinium Museum had opened in 1938 but was requisitioned by the Air Ministry early in the war for the storage of RAF records.

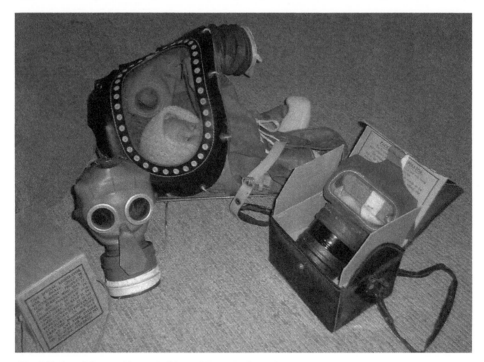

The Mickey Mouse (front left) and Baby's Respirator

This standard civilian gas mask (on the right) was issued to E. Stallard of Quenington. The Mickey Mouse mask (on the left) was issued to children between the ages of two and six years and a standard civilian to the general public over the age of six years; this one belonged to Jean Scott of Purton. There were numerous other designs for use by the military and ARP services. The baby's respirator (in the centre) was for infants two years and under and was issued after the outbreak of the war.

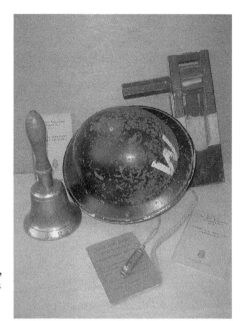

Air-Raid Warden's Equipment

Among the equipment given to air-raid wardens was a whistle, to warn those nearby of an imminent raid; a rattle, to signal the presence of gas; and a hand-bell, to signal the end of a gas alarm. Training for wardens and all other Civilian ARP services were posted each week in the *Wilts and Gloucestershire Standard*.

Lorry, Car and Bicycle Headlamp Restrictors

The lorry, car and bicycle headlamp restrictors were necessary when lighting regulations to foil enemy aircraft at night were enforced. Kerbstones, trees and other obstructions were painted white to help motorists. The blackout was tested on Saturday 2 September 1939 and fatal results, such as when Sarah Day, the wife of the landlord of the Three Magpies Inn, near Fairford, was killed by a passing car. She was the first of many to be killed or injured as a consequence of the blackout.

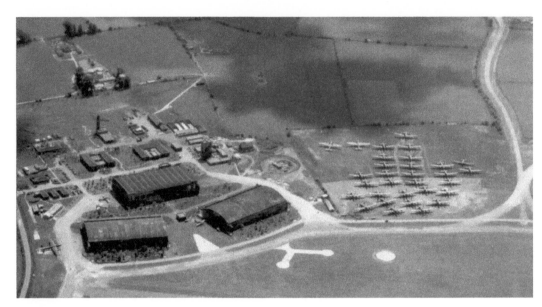

Aerial View of the Main Site, Kemble, 1940s

A rapid expansion of the RAF saw South Cerney joined, in 1938, by the aerodromes at Kemble and Aston Down, the latter a development of the Minchinhampton Royal Flying Corps airfield from the First World War. The aerial view shows the main site at Kemble in the 1940s. Both bases were developed for aircraft maintenance and distribution and Kemble's large civilian workforce had first call on the houses on the newly built Chesterton estate. This skilled workforce, who came from all over Britain, many from less feudal industrial towns and cities, introduced different social attitudes less dependent on social position. They also filled the skies with the now familiar sound of aircraft engines.

Chapter 2
This Means War

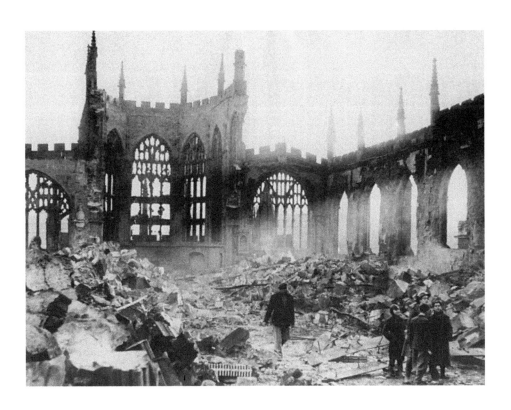

Dollar Street Offices of the WVS

Another of Cirencester's most valuable services created by the threat of war was the Women's Voluntary Service for Civil Defence (the WVS), which had its offices at No. 14 Dollar Street. Its leader in Cirencester was Mrs Patience Chester-Master.

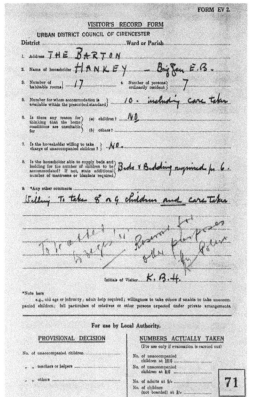

Evacuation Canvass Return from Brigadier General Hankey

In April 1939 the WVS canvassed Cirencester, compiling a register of all householders who would be willing to accept evacuees should the need arise. The register was put together from returns such as this one of Brig. Gen. Hankey, the town's Chief Air-Raid Warden, which is now lodged in the County Record Office. The Women's Institute members conducted a similar survey in the rural area.

Working of Evacuation Trains from Acton and Ealing Broadway—continued.

First Day—continued.

Train Number.		Empty Train.		Loaded Train.		Destination.	Empty Stock returned for same Day's Working.	
		Acton Yard.	Old Oak Common.	Acton.	Ealing Broadway.			Acton Yard.
		dep. p.m.	dep. p.m.	dep. p.m.	dep. p.m.		dep.	arr.
145		2†0	—	—	2 36	Bicester	—	—
146		—	2†15	—	2 45	Cirencester	—	—
147		2†10	—	—	2 54	Bruton	—	—
148		—	2†25	—	3 4	Bath	—	—
149		2†30	—	—	3 13	Andoversford	—	—
150		—	2†45	—	3 22	Wells	—	—
151		3†5	—	—	3 31	Swindon	—	—
152		—	3†6	—	3 40	Savernake	—	—
153		3†25	—	—	3 49	Bridgwater	—	—
154	L	3†30	—	—	3 58	Oxford	—	—
155		3†35	—	—	4 8	Weston-super-Mare ..	—	—
156		3†50	—	—	4 17	Shepton Mallet ..	—	—
157		—	3†45	—	4 24	Bath	—	—
158	L	4†5	—	—	4 33	Henley	—	—
159	West London	London	4†0	4 30	—	Weymouth	—	—
160		4†10	—	—	4 42	Swindon	—	—
161		—	4†10	—	4 51	Devizes	—	—
162	L	4†25	—	—	5 0	Maidenhead	—	—
163	L	4†30	—	—	5 9	Theale	—	—
164		4†50	—	—	5 18	Swindon	—	—

L—Non-corridor stock.

Cirencester's First Evacuation Train Timetable

On 1 September 1939, Cirencester's first group of evacuees set off from Ealing Broadway aboard evacuation train No. 146. On 31 August 1939 Vice-Chairman Wilson G. Tovey had told a special meeting of the Cirencester UDC that the evacuation would begin the following day, and Mr J. H. Wilkinson, clerk to the council, was appointed Chief Billeting Officer. This was just one of the many responsibilities he was given during the war and he was later given the OBE for his devoted service.

An Evacuee's-Eye View of Cirencester Town Station

Over 500 evacuees arrived at Cirencester town station on the afternoon of 1 September to be billeted in the town. They were children from Bifrons Senior School and Cambell Junior and Infants School in Barking, with their teachers and helpers, together with a small number of adults with preschool children. A total of 340 children and teachers from other London schools, who were to be billeted in the rural district, had detrained at Kemble to be bussed away to their destinations.

Stratton Evacuees with Their Teacher
The evacuees for the town were processed in the Corn Hall, which was efficiently organised as a reception centre. From here the evacuees were taken by the billeting officials to their billets. These evacuees were billeted in Stratton and were taken to the Stratton Village Hall by coach. Over the next five years, well over 2,000 official evacuees passed through the Cirencester reception centres at the Corn Hall and Congregational schoolrooms in Dyer Street.

A Group of the First Evacuees at Abbey House, September 1939
This postcard showing the first evacuees in front of the Abbey House in September 1939 was produced for the children to send home to put their parents' minds at rest. There were seventeen evacuees billeted in the Abbey House as guests of the tenants, Major and Mrs Dugdale. Most of the newly arrived evacuees, like the rest of the population listening to the wireless at 11 a.m. on Sunday 3 September, heard Prime Minister Neville Chamberlain declare that Britain was at war with Germany.

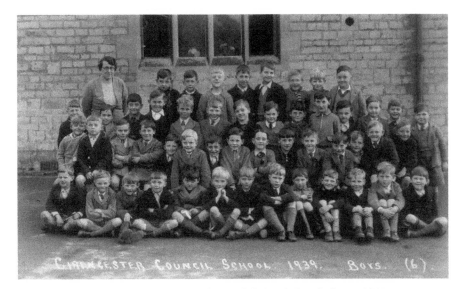

Class 6 Boys with Miss Cook at the Council School, Lewis Lane 1939
The school's numbers were swelled with the evacuees and the schoolrooms of the Baptist and Congregational churches had to be requisitioned to accommodate them. Leigh Heath School, Leigh-on-Sea, was one of the private schools to arrive in Cirencester. It was run by two sisters, Zoe and Hillie Sergeant, at Arkenside, opposite the Council School. Other than those already mentioned, the schools whose pupils were evacuated to the area included Russell Central in West Ham; Barking Girls Senior School in Princeton Street, Holborn; Westbury School, Barking; Salisbury Road School, Willesdon; Salisbury School, East Ham; Salisbury Avenue School, East Ham; Chamberlayne Road and Kensil Rise Schools in Willesdon; and others from Eastbourne. Some evacuated schools were dispersed between the town and villages.

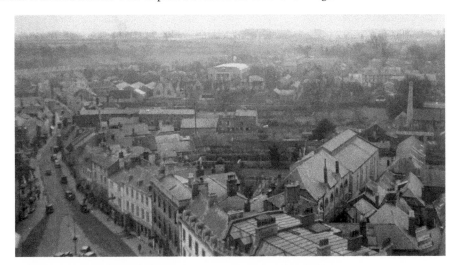

The View from the Parish Church Tower Looking South-East
Towards the end of 1939 an evacuee climbed to the top of the parish church tower and took photographs from this vantage point. The photographs show that after around four months the war had had little effect on the town's appearance. Looking south-east, the Corn Hall, with its two prominent chimneys and arched windows, is visible in the right. It was used as the reception centre for evacuees and for many other functions. In the background is the almost new Regal Cinema.

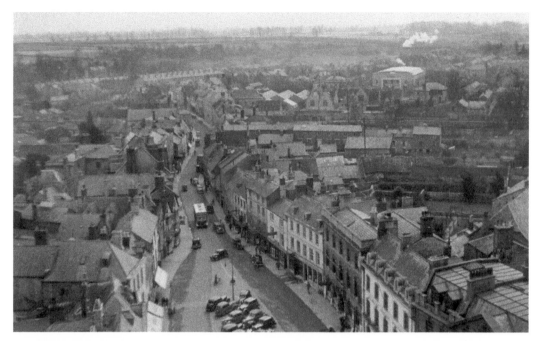

The View from the Parish Church Tower Looking East
Looking east, the car park is well stocked with civilian vehicles as this was before petrol rationing and installation of the large static water tanks in the centre of the Market Place reducing parking space.

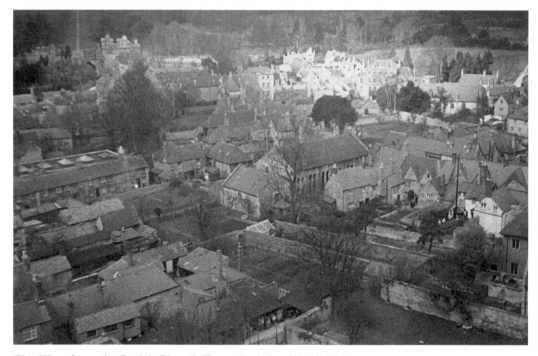

The View from the Parish Church Tower Looking North-West
Looking north-west, the Baptist church is prominent in the centre with its schoolroom, which was used by the evacuated Russell Central School.

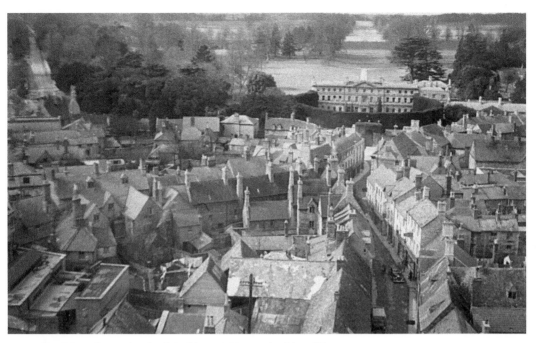

The View from the Parish Church Tower looking West
Looking west, the mansion – seat of the Bathurst family – fronted by the famous yew hedge stands out with the park beyond. The yew hedge was later allowed to grow unkempt to make it less distinguishable to enemy aircraft.

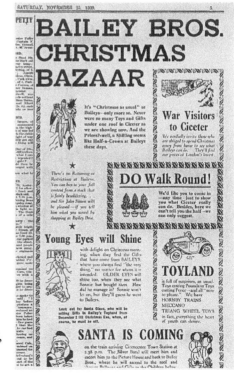

Bailey Bros' Christmas *Standard* Advert
As the first Christmas of the war approached, local businesses such as Bailey Bros department store advertised in the *Wilts and Gloucestershire Standard*, issuing invitations to the new arrivals in town to sample their wares.

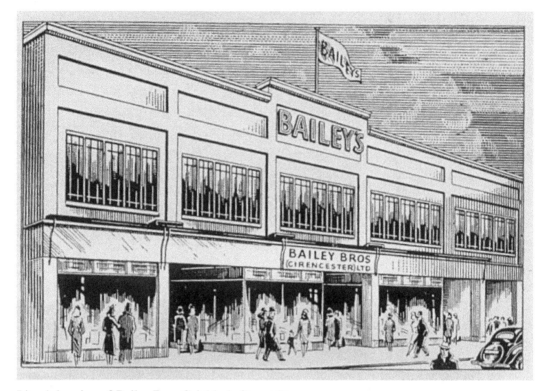

Lined drawing of Bailey Bros Cricklade Street Store
The Bailey Bros store in Cricklade Street could boast as many departments as most London department stores. This 1920s-style building was situated on the site now occupied by the Bishop's Walk shopping precinct.

Bailey Bros' 1939 Catalogue
For the first wartime Christmas, the Bailey Bros toy department could still offer the same range as in previous years, including these model aircraft advertised in 1939. Almost 700 children, including most of the evacuees, visited Father Christmas at the store during the first two hours after his arrival on 2 December.

28

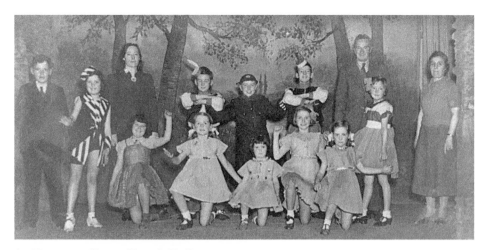

An Evacuees Show, Church Hall
The evacuees put on a show at the Church Hall in Cricklade Street, opposite the Maltings. The hall had been requisitioned as a canteen and social centre for the evacuees and here they put on entertainment for themselves and the public.

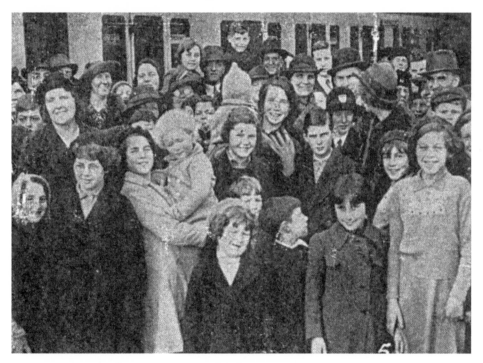

The Crowded platform from the Christmas special
The Urban and Rural District Councils combined to put on entertainments for the evacuees, arranging a Christmas at the Regal Cinema for them as well as for the children of service personnel and poorer families. Over 1,000 attended, and the programme included the cartoon film *Alice in Wonderland*, conjuror Herbert Milton from London, ventriloquist Corporal Bob Fitch with his assistant Winkie, and a sing-song led by 'Taffy' Evans with Miss Doris Pinmill on the piano-accordion. There were refreshments and a gift of two bars of precious chocolate and five shillings. This set the precedent for the next four years, with an ever-increasing clientele.

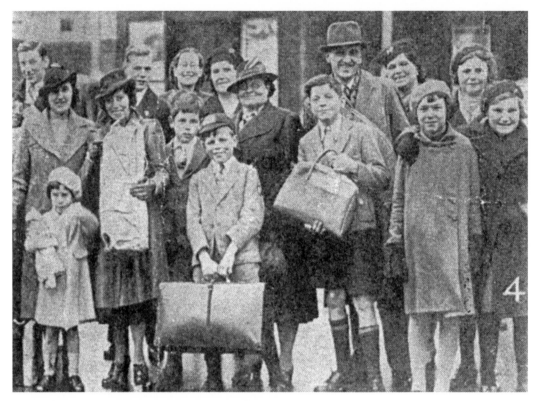

Happy Reunions on the Town Station Platform

Heading into Town for a Few Hours Together

To encourage evacuees to stay put in the reception areas for Christmas, the government arranged special trains for parents and relatives to visit the children in their foster homes. Cirencester's evacuees welcomed their special train from Paddington on 10 December 1939. As the train arrived there were happy reunions on the platform before the children and their relatives headed into town for a few hours together. When they waved goodbye at the end of the day, all of the children remained with their foster families.

Ice-Laden Trees

The ice-laden trees were the result of a freak ice storm. The year 1940 began with little action, but on the night of 27 January many thought they heard the sound of gunfire and explosions. However, the noise was of breaking limbs from trees and collapsing telegraph and electricity poles during a freak ice storm. The rapid alternate freezing and thawing of rain, which continued for two days, caused a build-up of a thick layer of ice everywhere. The storm brought down hundreds of trees all over the area, causing considerable disruption to power supplies and communications.

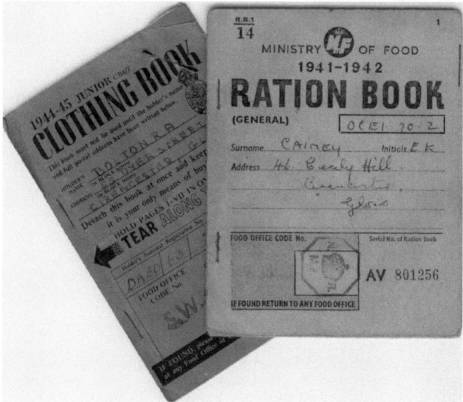

Food and Clothing Ration Books Issued in Cirencester

The rationing of essential foodstuffs began in January 1940, followed by clothing, furniture and petrol. The UDC food and fuel office was run by Mr Greenland at No. 3 Dyer Street and the RDC office under Mr Hall at the Barton Hall; in 1945 they combined at No.3 Dyer Street. Next door the Bingham Library was requisitioned at the beginning of the war and the books moved to the Oakley Rooms in Dyer Street as a temporary alternative. After remaining empty for a year, the Bingham Library building was used as a canteen and rest centre for service personnel.

The Old Police Station, Park Lane
During the evening of 14 May 1940 and during the next day, 160 men signed up for the Local Defence Volunteers (LDV) at the police station in Park Lane, following an appeal for volunteers by the Secretary of State for War, Anthony Eden, over the wireless. The uniform for the LDV was a basic armband, and weapons often had to be improvised. Knives, cudgels and pitchforks compensated for a lack of firearms. Their initial task was to watch for enemy parachutists.

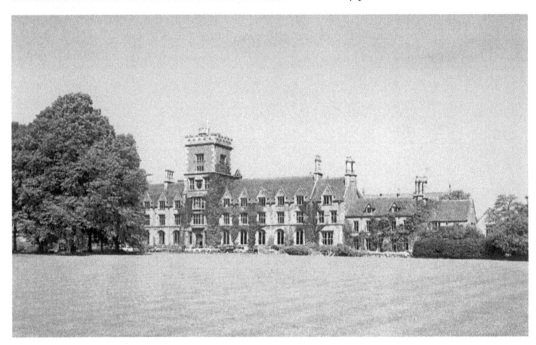

The Royal Agricultural College
The Royal Agricultural College was requisitioned for the thousands of men of the Infantry Brigade commanded by Brigadier Brian Harrick, who arrived in Cirencester Park in the aftermath of Dunkirk. Most of the men lived under canvas, but the college was used as accommodation and canteen facilities. To cope with the transit of men and equipment, Brigadier Harrick imposed a one-way traffic system in the town, many elements of which survive today.

INVASION.

THE FIRST THING is to BELIEVE that Invasion will come, for unless you believe, you won't go all out to train for it. Doubt and wishful thinking are Fifth Columnists: get rid of them.

THE SECOND THING is to REALISE what we shall be up against. Invasion will probably start with the biggest air raids ever known. Gas will be used. The enemy's aim will be to upset morale and weaken our will to resist ; to hamper and destroy production ; to bring normal life to a standstill ; to create fear. Air-borne troops may be dropped all over the countryside for the purpose of causing chaos, havoc and death. No air force, however large, can prevent some air-borne troops landing somewhere. Remember—if we lose Britain, we lose the War. There will be no second chance. We must have ONE common aim and ONE only—to destroy the enemy.

THE THIRD THING is to PREPARE for Invasion. Every fit man and woman should now have two jobs—the ordinary one and the National Service one. Make your National Service job your hobby ; put your back into it and learn it thoroughly so that you may know what to do when you have to do it. Don't let the suddenness of Invasion catch you unawares.

THE FOURTH THING is to KNOW quite certainly what your Defence Committee is doing to prepare for Invasion and that the Defence Committee know what you are doing. If you complete the form delivered with this card and hand it to the collector, who will call, they WILL know.

THE FIFTH THING is to KEEP FIT and perfect in your chosen Invasion job by constant practice. By so doing you will help to preserve a united opposition to the invader; you will be ready to take your part in driving out and destroying the enemy ; you will ensure that your neighbours STAND FIRM ; you will make it your duty to hinder and frustrate the enemy by every possible means.

Issued by the Cirencester (Urban) Defence Committee.

CUDC Invasion Information Card
In the aftermath of Dunkirk, the CUDC's newly formed Defence Committee issued instructions to householders on what to do in the event of the invasion by enemy forces, which seemed distinctly possible at the time.

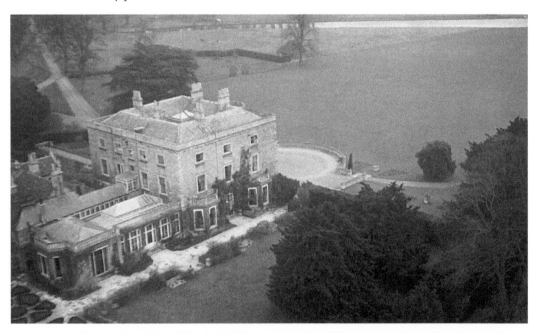

Abbey House, Battalion HQ of 3rd Gloucestershire (Cirencester) Battalion Home Guard
In July 1940 the LDV was renamed the Home Guard and Cirencester was given its own Battalion. Abbey House was used as the battalion headquarters of the 3rd Gloucestershire (Cirencester) Battalion, with Lieutenant Colonel Dugdale as Battalion Commander. With the dearth of weapons in the country, his gun room was of considerable importance. The battalion originally consisted of six companies, covering the Cirencester police district, but eventually the RAF Kemble Platoon became a company in its own right – G Company – bringing the Battalion strength up to seven companies of some 3,000 men. In 1942 Colonel Dugdale retired and Colonel Robinson took command.

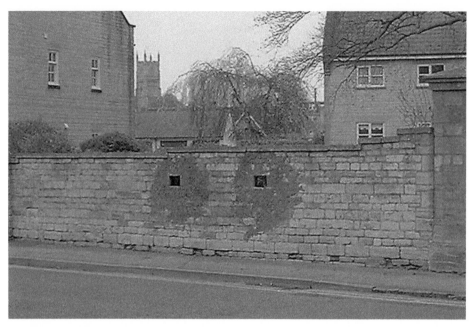

Loopholes with Camouflage Paint Still Intact, Oxford House Garden, London Road
During the summer of 1940, with the Battle of Britain raging in the skies above, the Home Guard prepared their meager resources for the defence of Cirencester district, should invasion come. Loopholes with their camouflage paint intact can still be seen in the wall of Oxford House in London Road. Gun emplacements and roadblocks were set up at strategic points around the town and in the countryside. Derelict cars were put into the fields to prevent enemy glider landings.

C Company Outside Their HQ, Cecily Hill Barracks
'C' Company was designated to defend Cirencester itself, commanded by Major Gillman. Their headquarters were in the barracks in Cecily Hill, although many decisions were made lower down the hill in the Dolphin Inn.

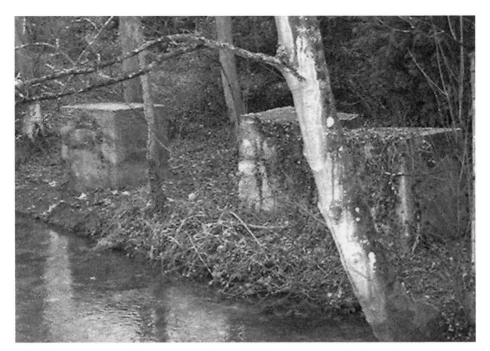

Grove Lane Tank Traps

Concrete tank traps were cast at various strategic points along Grove Lane and in the vicinity of both of Cirencester's railway stations – Cirencester was designated an anti-tank island. From the German invasion plans it was known that a force would come north from Dorset and Devon, skirt around Swindon until they reached the A40 road north of Cirencester. They would then swing around Oxford, trapping London. The Cirencester Home Guard orders were to man the defences and hold out at all costs until the field army being assembled in the Worcester area could relieve them – a chilling prospect.

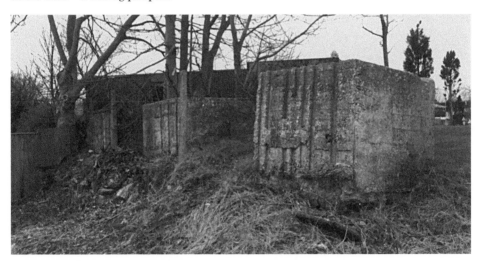

Watermoor Railway Tank Traps

The only reminder today of the railway station and line at Watermoor is this line of tank traps. The line formed part of an elaborate one-way rail system bringing war materials from the industrial North.

The Great Western Railway Company of the Home Guard

The local railway men from Cirencester's two stations, Kemble station and Tetbury station, and Coates sidings formed the great Western Company of the Home Guard. The unit was mainly responsible for patrolling the track before ammunition trains or special trains. Their commanding officer was Mr Feldwick, who was the stationmaster at Kemble, and their headquarters was the Thames Head Inn! The GPO also had its own Home Guard unit in Cirencester, which was responsible for defending Post Office and telecommunications installations.

Hatherop Platoon of the Home Guard

Most of the villages had their own Home Guard Platoon. Hatherop Platoon was trained by a regular army sergeant stationed at Hatherop Castle. Unbeknown to them, he also trained Danish members of the Special Operations Executive (SOE), whose secret Danish section training headquarters was in the castle.

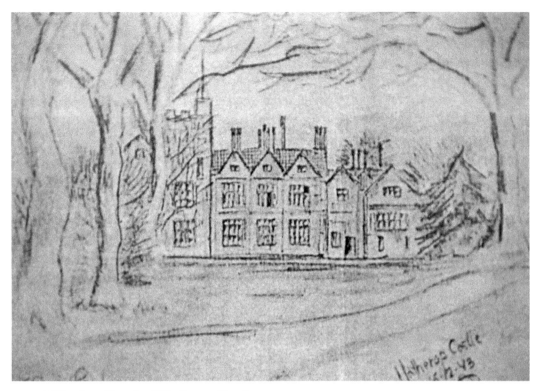

A Wartime Sketch of Hatherop Castle

This sketch of Hatherop Castle was made by a Danish policemen retraining at Hatherop Castle as an SOE agent. Agents also learned the technicalities of explosives and sabotage, and a section of salvaged German aircraft fuselage fixed in the trees was used for parachute training.

Down Ampney Home Guard Tree

Still in situ in Down Ampney is a tree with a steel cable tied around it, ready to be stretched across the road. This was the Home Guard's gruesome method of decapitating enemy troops travelling by motorcycle or open-topped vehicles. Other defences set up by the Home Guard included fougasse installations, which were placed beneath Siddington Railway Bridge and at other points around the district. 500-gallon drums of flammable liquid were set into the roadside verges and as an enemy tank passed a fuse would detonate, sending a jet of flame across the road.

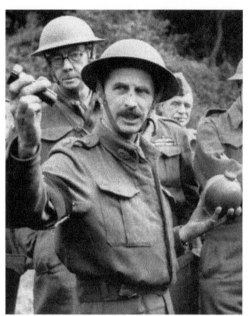

Sticky Bomb Demonstration

One of the Home Guard's strangest weapons was a grenade known as a 'sticky bomb', a spherical glass container of explosive coated on the outside with a layer of thick glue, all of which was fixed to a handle containing a fuse. Surrounding the explosive was an outer casing of two aluminium hemispheres held together by a split pin. Once the bomb was fused the pin was released and the outer casings discarded. The user had then to approach the enemy vehicle and stick the grenade in place or throw it in the hope that it would stick. The concrete tank traps around Cirencester were to provide cover for would-be sticky bomb throwers.

Watermoor Railway Bridge Looking North Towards the Sands

The Home Guard had gun posts on the town's railway bridges. Access to Watermoor Railway Bridge was difficult as a high wall and advertising hoarding blocked the way. The only way to reach the bridge parapet was through the last house before the bridge. The men had to go through the front door and up the stairs, climb out of the main bedroom window and slide down an outhouse roof onto the back garden, then climb the bank. The occupants, the Kimber family, were inconvenienced every time there were training sessions.

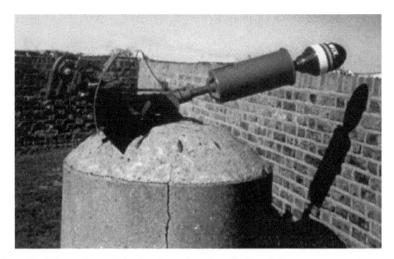

Gun Pivot for Mounting a Blacker Bombard or Spigot Mortar

At strategic points around the town there were gun positions with stainless-steel pivots set in a concrete cylinder to mount Blacker Bombards or spigot mortars. Such positions were found on the raised garden of the Sands on the town side of Watermoor Bridge, the north side of Somerford Road Bridge and at the junction of Spittlegate Lane and Abbey Way.

The Blacker Bombard was a simple mortar mounted on a tripod. 'C' Company had one mounted on a railway ganger's trolley positioned initially beneath Chesterton Lane Railway Bridge – this bridge had wooden doors across the arch to slow down Germans coming by train. In the event of a German breakthrough, the Home Guard would propel themselves to the Somerford Road Bridge for the next stand. All the railway banks were also protected by barbed-wire entanglements.

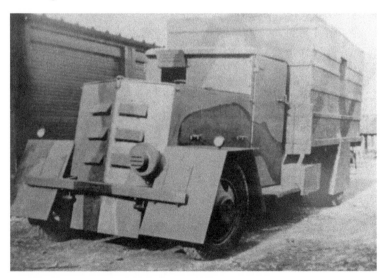

Cirencester Home Guard's Armoured Lorry

The Home Guard constructed an armoured vehicle on a Dodge lorry chassis. The work was done at Hope's foundry with the front of the vehicle and cab covered in steel plate. The rear accommodation for the troops was one large wooden box within another, with the intervening space filled with sand. In tests, machine-gun bullets penetrated the steel plate in places, but only penetrated the outer wooden box, the sand absorbing the force.

Parish Church Vestry, Home Guard Gun Position
Provision was made for rifle positions on the vestry roof and other parts of the parish church, for the last stand. Small field pieces known as Smith guns were positioned around the town, including the Gloucester Street Bridge and at RAF Kemble. The flat area of land adjacent to Gloucester Street Bridge was also designated as a minefield.

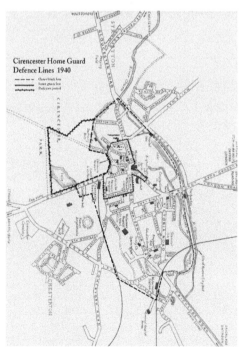

Home Guard Defence Map
This map shows the Home Guard defence lines. Cirencester was to be defended in two stages, the initial defences protecting an area almost equivalent to that of Roman Corinium. Should the enemy break through, the defenders – consisting of the Home Guard, men of the 220 Company Pioneer Corps, elements of the RAF and the New Zealand Forestry engineers working in Cirencester Park – would draw back to a central area bounded by Ashcroft Road, Sheep Street, Park Lane, Park Street, Thomas Street, Dollar Street, Gosditch Street, the Market Place and upper Cricklade Street.

Cirencester's Special Constabulary

To maintain civil order, the police force was augmented by Police War Reservists and the Special Constabulary, shown here. Much of their time, however, was spent in enforcing the blackout regulations. The Specials kept an unofficial league table noting who had apprehended the highest of local society. One titled lady was fined £10 for not only 'showing a light', but for 'being extremely rude to the warden'. The normal fine for an offence was £1, including 2s 6d for the Special's loss of earnings through attending court during working hours, a cost not met by the employer.

SW/URB MINISTRY OF FOOD. 47

SOUTH WESTERN DIVISION, BRISTOL, 8.

To THE HOUSEHOLDER.

EMERGENCY FOOD RATIONS.

Emergency Rations consisting of biscuits, tinned meat, tinned soup or beans, tinned milk, sugar, margarine and tea have been stored in your district, and will be distributed by your Local Food Officer in the event of invasion. Notice will be given locally of the time and date at which the distribution is to take place at the address given below.

TAKE (1) Ration Books for yourself and other members of your household.
WITH (2) SIX shillings for each ration.
YOU (3) A basket, sack, pillow case or clothes basket big enough to carry home the rations.

EACH RATION is bulky and weighs about nine pounds so you may need someone to help you.

R. H. BECKETT, Divisional Food Officer.

Address of distribution Centre: _Gilletts_

West Market Place

Any enquiry regarding this matter should be addressed to your Local Food Officer or Voluntary Food Organiser, and NOT to the above address.

KEEP THIS CARD FOR FUTURE REFERENCE.

An Emergency Ration Card Issued in Cirencester

Householders were issued with an emergency ration card to be taken to a specific store should invasion come. The card show was issued to No. 7 Dyer Street and instructed the occupier to go to Gillett's shop in West Market Place. These food rations stores were at various shops in town and at locations in the countryside; protecting them was one of the other duties of the Special Constabulary.

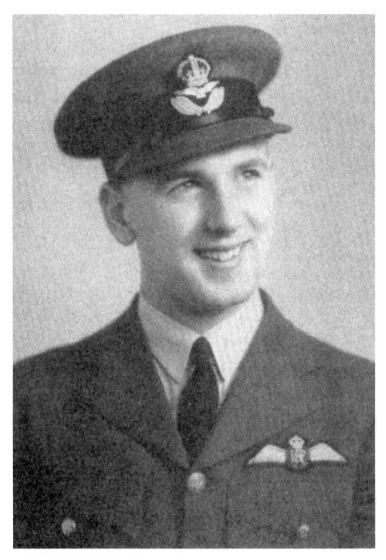

P/O Charles Alex Bird
While those on the ground prepared for invasion, local airfields were fully
engaged in the Battle of Britain. Aston Down, Bibury, Kemble and South
Cerney were all bombed by the Luftwaffe. On Thursday 25 July 1940, Pilot
Officer Charles Alex Bird from Kemble took off in a Hurricane – part of
the station's Defence Flight – to engage with a raider over the Stroud area.
Unable, for some reason, to use his guns, he deliberately collided with the
German Bomber, which crashed at Oakridge. Three of the four German
crew survived, but Pilot Officer Bird died in the wreck of his aircraft.

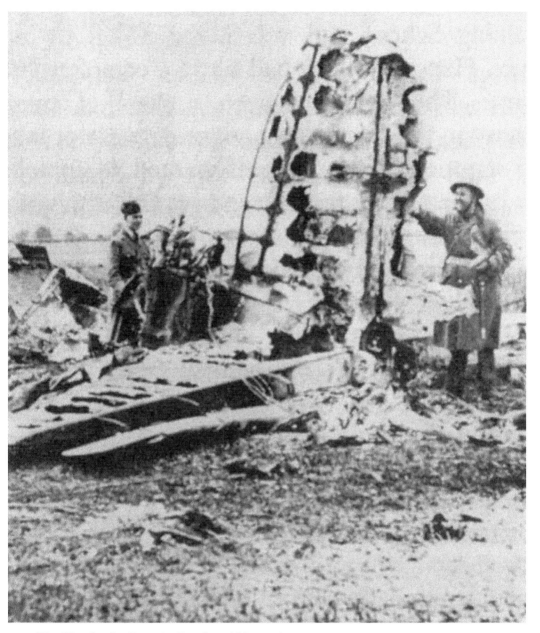

The Wreck of a German Bomber, Aldsworth

A German bomber crashed at Aldsworth after a similar action on Sunday 18 August 1940.
When Sergeant Bruce Hancock was returning to his base at RAF Windrush on night-flying
training he encountered a German Heinkel bomber that had just bombed the airfield. In the
action that followed Sergeant Hancock collided his Anson trainer with the enemy, killing
himself and all the German crew. Sadly neither Pilot Officer Bird nor Sergeant Hancock
received the credit due as 'One of the Few' because they were not assigned to combat units
officially engaged in the Battle of Britain.

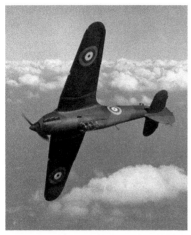

Hawker Hurricane in Flight

German Aircraft Pump

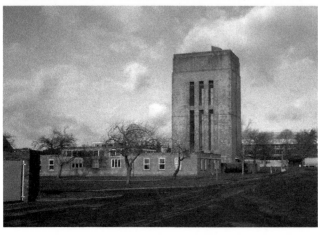

Kemble Water Tower

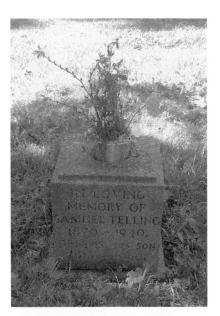

Sam Telling's Grave, Ashton Keynes Churchyard
On Sunday 16 September 1940, at the height of the
Battle of Britain, Ashton Keynes was bombed. A number
of cottages were damaged, causing civilian casualties
including Sam Telling, a retired groom, who was
killed when his cottage in Rixon Gate was completely
demolished. He was the only civilian to be killed by
bombing within 10 miles of Cirencester, apart from on
the airfields. He was buried in Ashton Keynes churchyard
and among the wreaths at his funeral was one from
the Bruderhof. With the deteriorating situation, the
government was unable to guarantee the Bruderhof's
safety and suggested internment for its German members
or assistance with emigration. The Bruderhof chose to
emigrate to the jungles of Paraguay at the end of 1941.

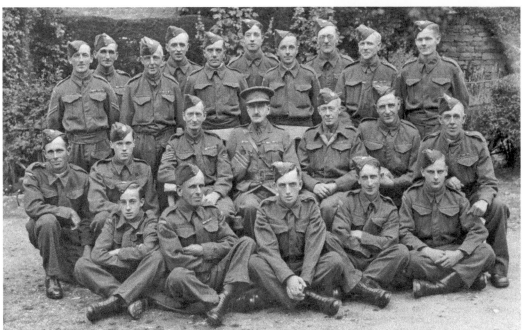

E Platoon of Cirencester's Home Guard
During the time when it was thought that invasion was imminent, E Platoon of the Home Guard was on
foot patrol in Cirencester Park when they saw what they thought was a parachutist landing. They sent
word to the Barracks for Mr Bloxham, the duty bell-ringer, to rouse the town. He went to the parish
church bell chamber and locked himself in with a guard at the door. On examination, the 'parachutist'
was revealed to be a piece of barrage balloon', and so a member of the Home Guard and policemen
went to stop the ringing. At the door, the guard first threatened to shoot them as they had no written
orders but reluctantly allowed them to persuade the bell-ringer that they were not the enemy and to
stop ringing. No one in the town seemed to have taken any notice of this invasion scare.

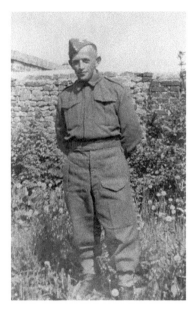

Czech Soldier Emile Ohme
At this vital time a number of anti-aircraft batteries were located around the area to protect the airfields. The Home Guard unit at RAF Kemble operated AA guns on the airfield. Emile Ohme was a Czech soldier working on the battery at Upper Siddington. He was one of the thousands of men and women from the occupied countries who found their way to Britain in order to fight back.

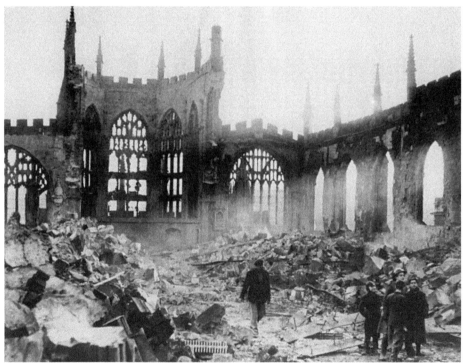

Blitzed Coventry
With the darkness of autumn came the enemy bombers. 14 November 1940 saw one of the most notorious aerial actions of the war – the target was Coventry – shown here in the aftermath of destruction. Cirencester escaped almost unscathed but there was a steady stream of enemy aircraft above the town, heading towards the North and the Midlands following the radio beam from Cherbourg and using the prominent landmark of the parish church tower. When morning came they often returned to base, following the Watermoor railway line to Southampton and the coast.

Eye witness Ralph Wilkins, Age Five
Many eyewitnesses, including five-year-old Ralph
Wilkins, watched during the late afternoon of Sunday
24 November 1940 as a drama unfolded in the skies
over Cirencester. A German Ju88 reconnaissance
aircraft returning from photographing the aftermath
of the Coventry raid was pursued from Baginton
airfield near Coventry by three RAF Hurricanes. One
returned to base with engine problems but Polish pilot
Sergeant Mieczylaw Parafinski and Wing Commander
John Oliver pressed home their attack over the
Cotswold countryside.

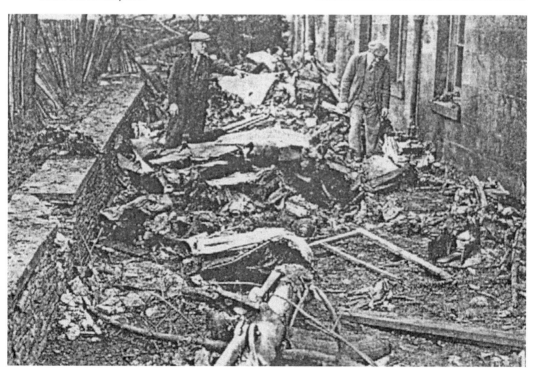

The Wreckage of the Ju88 at Coates Manor
Over Cirencester, flames began to pour from the enemy aircraft and pieces of wreckage broke away as
Sgt Parafinski's bullets hit home. All four of the German crew died in the flames as their doomed aircraft
crashed at the back of Coates Manor.

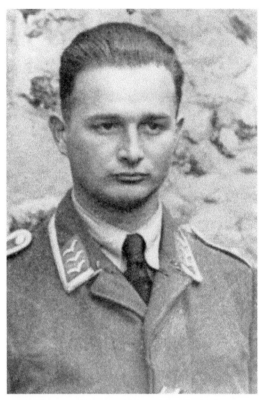

Feldwebel Helmut Schingshankl the Austrian Pilot of the Coates Ju88

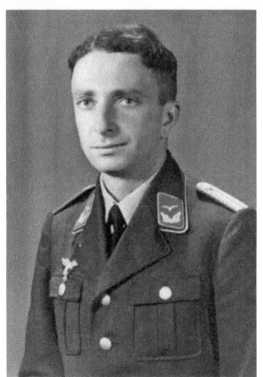

Leutnant Herbert Holstein, The Observer

The crew of the Ju88 included the Austrian pilot, Feldwebel Helmut Schwingshankl (above), and observer Leutnant Herbert Hollstein (left), as well as flight engineer Unteroffizier Gustav Koch and wireless operator Gefreiter Hans Kran. They were initially buried in Coates Churchyard, then, in the 1960s, reinterned in the Military Cemetery on Cannock Chase. Sergeant Parafinski was killed on a training mission on 26 February 1941.

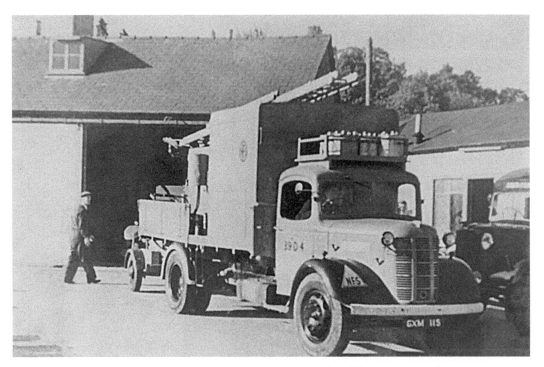

An NFS Fire Appliance at the Fire Station, Canal Wharf Depot, Sheep Street

At the beginning of the war, auxiliaries were added to the volunteer fire brigade and a rapid training schedule began. The volunteer and auxiliary fire services were amalgamated under the National Fire Service (NFS) scheme in August 1941. This NFS fire appliance was based at the fire station in the Canal Wharf depot Sheep Street. Although the NFS did have to tackle Blitz conditions in Cirencester, they joined the town's ARP mobile column to assist during the bombing on Bath and Bristol. They also attended numerous air crashes and road accidents, many of which were fatal. One fatality occurred when Fireman Mills fell from the engine while attending an incident at Fosse Bridge.

The Temperance Hall, Now The Salvation Army Hall

The Temperance Hall in Thomas Street, which is now The Salvation Army, was set up as the ARP first aid headquarters. It had a staff of forty, under the supervision of Dr Westwood. Mrs Pardoe, the wife of ARP sub-controller Colonel Pardoe, was First Aid Commandant. It had first aid and surgical equipment to meet any emergency. The staff were at constant readiness with a shift on call at all times.

Mr Woodward and His Son from Next Door, Photographed by the Sandbagged Hall
A sandbag blast wall protected the Temperance Hall; the sandbags can be seen here behind Mr Woodward and his son, who lived next door to the hall. On 27 April 1942, a German bomber skimmed the town, expending spare ammunition and striking the front of the hall. During this incident a first aid party answered a call to collect a wounded policeman from a house in Gloucester Street. On arrival they were surprised to find that the injured 'copper' was the boiler, which had been damaged when a shell came through the kitchen window. A washing boiler in those days was known as a copper!

The Memorial Hospital Air-Raid Shelter
A substantial concrete air-raid shelter was built at the back of the Memorial Hospital, which was the town's main hospital treating the civilian population and, occasionally, military personnel. The shelter was designed to accommodate eighty of the staff and patients, with bunks along the west wall and benches opposite. Patients from the first floor of the main building reached it via a canvas chute leading to the north entrance. It was manned every time the siren sounded, which was more than 120 times.

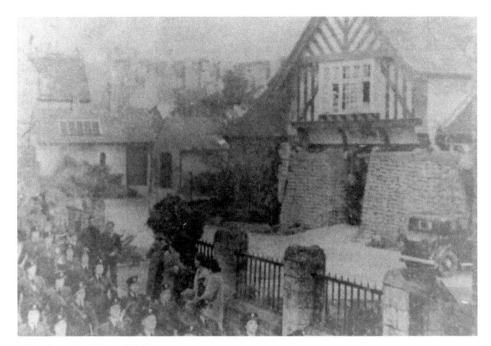

The Hospital Blast Wall
A blast wall protected the ground floor of the hospital and those patients too ill to move remained in the main building, cared for by designated staff.

The Brewery Air-Raid Shelter, Cricklade Street
Some private companies had air-raid shelters for their staff. The Cirencester brewery shelter, which was for staff and nearby residents of Cricklade Street, had anti-gas detector discs at its entrance. A number of Anderson and Morrison shelters were distributed within the district, but in town major buildings such as the Corn Hall, the Maltings and Mead House had their basements strengthened with timber supports or steel girders to provide emergency shelters.

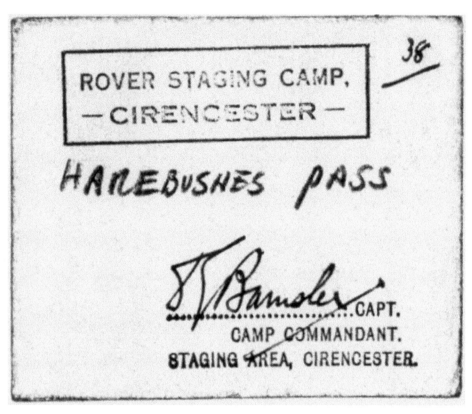

ROVER STAGING CAMP,
— CIRENCESTER —

HAREBUSHES PASS

.....................................CAPT.
CAMP COMMANDANT.
STAGING AREA, CIRENCESTER.

Hare Bushes Pass Issued to the Goodram Family
A large military transit camp was located at Hare Bushes, between Burford Road and the Whiteway. The Goodram family was issued with this pass as they were tenants of a cottage that found itself surrounded by the camp. The camp may have been the intended target when a German bomber dropped bombs on Whiteway Farm. An armourer from RAF South Cerney was sent to the scene to defuse an unexploded bomb and some livestock were killed in the raid. Veterinary facilities had been set up at the mews at the Long House in Coxwell Street to treat animals injured during raids, and duty slaughtermen visited outlying farms where necessary.

The Site of the Evacuee Children's Hospital
The premises of seed merchant John Smith's at No. 33 Cricklade Street were taken over to be converted to a hospital for evacuee children. With the beginning of the Blitz in 1940, the influx of official and unofficial evacuees continued and more facilities were needed. The hospital had twenty-five beds and Sister-in-Charge Daisy Bracher and her staff cared for those suffering from anything from measles and scabies, to tuberculosis. The former Chesterville School at No. 2 Querns Hill was requisitioned as an adult evacuee hostel with clinic. Orphaned children were taken in at the Public Institution workhouse, which later became the Watermoor Hospital and is now the CDC headquarters.

The Querns Babies' Convalescent Home
Some of the youngest victims of the Blitz were cared for at the Querns, which provided convalescent facilities for young babies injured as a result of enemy action. After the war the Querns became Cirencester's maternity hospital. During the war, the Cotswold Hospital in Tetbury provided maternity provision for the mothers of Cirencester, including the writer's own mother. This often required a hazardous journey by ambulance in the blackout and bad weather.

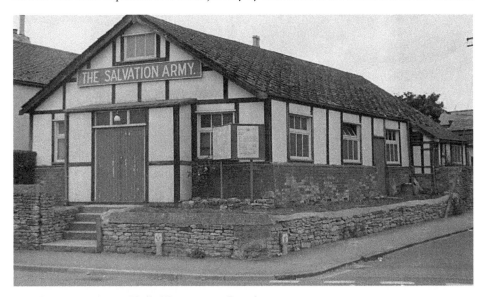

The Salvation Army Hall, Watermoor Road
On weekdays, evening-play facilities for evacuees were provided at the Salvation Army Hall in Watermoor Road, the Methodist Church in Ashcroft Road and at the Mission Room at the eastern end of Chesterton Lane close to the junction with School Lane.

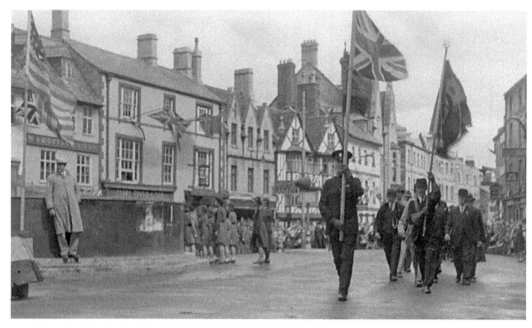

A static water tank outside Boulton's shop in the Market Place

Emergency water supplies for ARP were positioned at various points around the town. The static water tank on the left of this picture was situated outside Boulton's shop in the Market Place. This was one of two tanks in the Market Place and there were also tanks at the lower end of Cecily Hill, the western end of the Avenue and at the junction of Chesterton Lane and Watermoor Road. There was provision for a canvas dam to be put across the river on the Oxford House side of Purley Road Bridge and the water from the swimming baths was also to be used, although not for drinking!

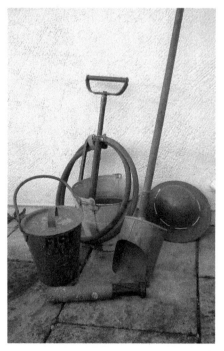

Fire-Watcher's Helmet, Incendiary Bomb, Bomb Shovel, Sand Bucket and Stirrup Pump

Another ARP service set up during the bombing was for fire-watching. The staff of business premises and factories and occupants of the main streets enrolled as fire-watchers to look out for falling incendiary bombs, attempt to extinguish them and inform the fire brigade. This picture shows a fire-watcher's helmet, an incendiary bomb, a bomb shovel, a sand bucket and a stirrup pump. At Bailey Bros department store the staff had instructions first to ring Miss Bailey, the owner, before the fire brigade, despite the fact that she was profoundly deaf. They would then run with the ledgers to the shelter beneath the Maltings.

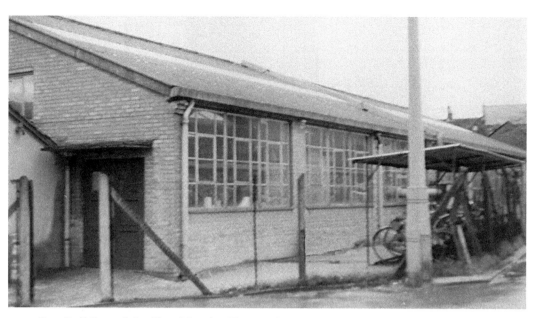

One Building of the Vast Mycalex Factory between Ashcroft Road and Castle Street
This building was part of the vast Mycalex factory in the centre of the town between Ashcroft Road and Castle Street. The static tank at the factory was tastefully painted with a rural landscape. Their fire-watchers were rudely awakened while on duty one night by the fire brigade coming to put out a fire in the office caused by an electrical fault. The ARP ambulance and other equipment was housed in the former Cotswold Garage, which came within the factory boundary.

Government Advice Leaflets
Public information leaflets were published by the government to advise on matters such as using gas masks. During the war, advice came from many sources. The vicar of Latton-cum-Eysey, Revd S. Claude Tickel, was a frequent correspondent in the *Wilts and Gloucestershire Standard*. He gave the following advice, which also appeared on the 1940 calendar of *Punch* magazine: 'In an air raid the best thing to do is to don a gas mask, sit astride a low wall and fall and lie down on the side the bomb is not falling.' Correspondence followed asking for advice should only a thorn fence be available and whether Hitler would put red lights on bombs at night. Perhaps his eccentricity helped defuse the tension at a very traumatic time.

55

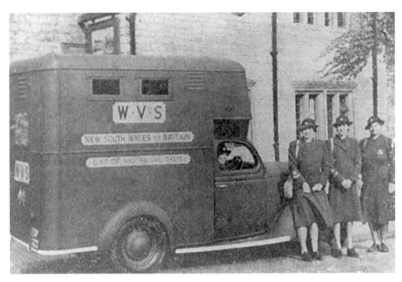

The WVS Tea Wagon Driven by Mrs Le Blanc-Smith outside the Waggon & Horses, London Road

Another diffuser of wartime tension was the ubiquitous cup of tea. The WVS tea wagon, which was driven by Mrs Le Blanc-Smith, is seen here outside the Waggon & Horses, London Road. This mobile canteen was donated by Mrs Abigail Davis of New South Wales, Australia. The WVS also had facilities in town and the villages around to provide emergency field kitchens to feed large numbers.

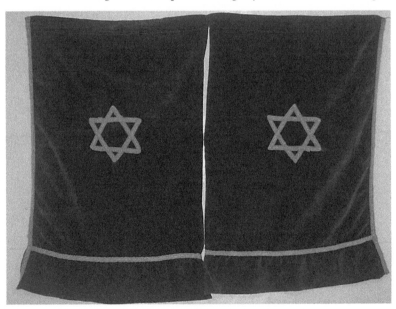

Worship in the Congregational Church Rooms

The 220 Company of the Pioneer Corps, which was made up of Jewish soldiers, was stationed in Cirencester from early in the war, at the Bingham Hall then Siddington Hall. Many other Jews came into the area as refugees and Revd Stanley Franklin, minister of the Congregational Church, allowed the use of one of his church rooms for their worship. This curtain was placed between the Torah and Jewish Congregation during the services. From 1942, Mrs Leonard Jones also ran a social centre for refugees at the Essex Hall in Coxwell Street, which later became the Kingdom Hall.

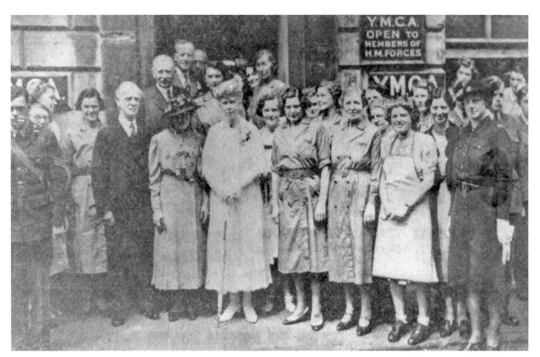

Queen Mary Visiting the YMCA Services Social Centre, Abberley House, July 1941
In July 1941, Queen Mary visited the YMCA Services Social Centre at Abberley House, one of a number of permanent social centres for service personnel coming into the district. At the YMCA there was a problem with members being unable to take advantage of their facilities unless they were in the forces, or wearing their Home Guard uniform. Other facilities were provided at the former Bingham Library, Masonic Hall and Congregational Church rooms. Queen Mary, seen visiting the YMCA, was living at Badminton and frequently visited Cirencester.

Chapter 3
A War on Many Fronts

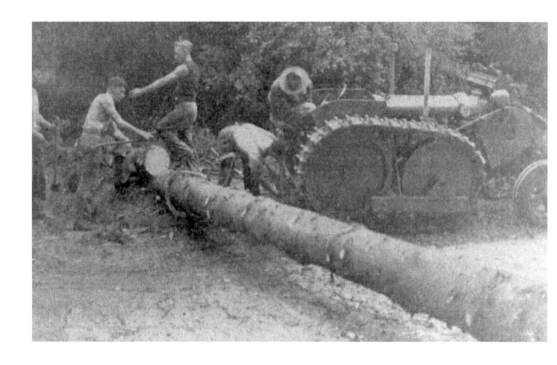

Land Army Girls in Fairford Carnival 1939
Land Army girls took part in the Fairford carnival in 1939. The Women's Land Army (WLA) came into being during the First World War to compensate for the many men who left the farms to fight in France, and the administrative organisation remained after the war ended. In July 1939 the service was reactivated and recruiting in the Cotswolds started straight away.

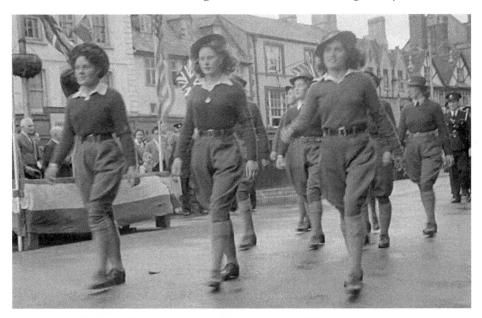

Land Army Girls on Parade through Cirencester in 1944
These Land Army girls were on parade through Cirencester in 1944. The WLA did invaluable work on farms in the Cotswolds. Their accommodation on farms was often very basic, but hostels were set up at Marston Manor, Chester Street, Stratton to provide more standard facilities. The girls had to learn skills that were alien to many who were from urban backgrounds – many developed their skills to become equal if not better than the regular farm labourers. All farming in Gloucestershire was supervised by the Gloucestershire War Agricultural Executive Committee, whose local machinery and equipment store was in one of the disused but serviceable buildings of the old railway works off Chesterton Lane, adjacent to Watermoor station's goods shed.

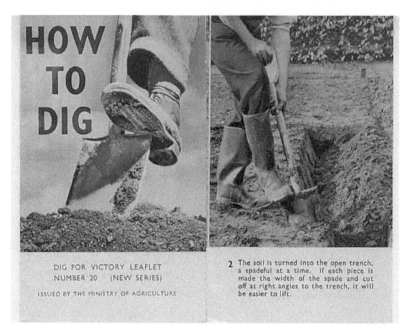

DIG FOR VICTORY LEAFLET
NUMBER 20 (NEW SERIES)

ISSUED BY THE MINISTRY OF AGRICULTURE

2 The soil is turned into the open trench, a spadeful at a time. If each piece is made the width of the spade and cut off at right angles to the trench, it will be easier to lift.

Dig for Victory Leaflet

Everyone, not only the WLA, was encouraged to 'Lend a Hand on the Land' and 'Dig for Victory'. Children were given time off school to harvest potatoes and pick fruit. There was plenty of advice to be had. Sometimes official advice and instructions flew in the face of local knowledge and farmers on the higher Cotswolds were loath to plough sheep pasture knowing that yields of cereal would be poor. Sadly, Ministry-enforced changes led to more than one suicide in the farming community.

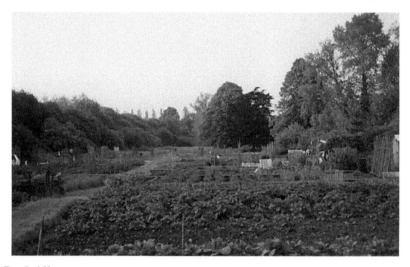

City Bank Allotments

Large areas of land were turned over to allotments. These allotments were at City Bank and there were others in Bowling Green Lane, London Road, Beeches Road, Love Lane, Chesterton Lane, Somerford Road, the Bull Ring and Stratton, many of which still exist today. At City Bank, part of the present playing field was cultivated to give extra space. Allotments were often outside the experience of city children: evacuee children returned to their foster home in Gloucester Street bearing various salad vegetables and announced that they had found the produce growing wild in a field.

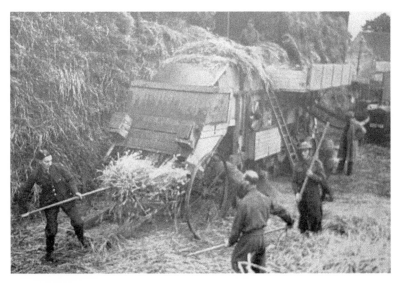

Aston Down RAF Personnel Help with the Harvest
On the local airfields the hay was harvested, silage made and, in some areas, cereals grown. Here, RAF personnel are helping with the harvest at Aston Down. The WI and other women's organisations were extremely busy in the late summer and autumn collecting fruit and vegetables for preserving. Jam making – with extra government sugar allocations – was undertaken on a monumental scale in the towns and villages. The Kings Head was the venue for the Cirencester 'factory'. Children also undertook the collection of rose hips to be turned into vitamin-rich syrup, and early each year schemes were set up for children to be paid for killing cabbage white butterflies.

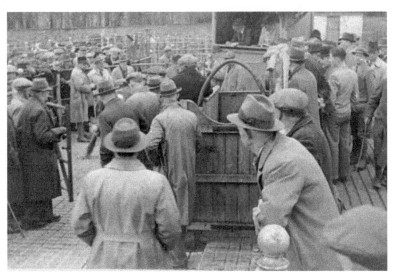

Cirencester's Recently Closed Cattle Market, 1940
This was Cirencester's cattle market. During the war, a busy market was an indicator of the success of the agricultural campaigns. Pig clubs were set up in the local towns and villages with householders separating out waste food from normal refuse to provide pigswill. The military camp canteens were also a rich source of waste food. There were two pig clubs in Cirencester: one for ordinary citizens and the other for councillors and officials. The main one was at The Beagles, Chesterton Lane.

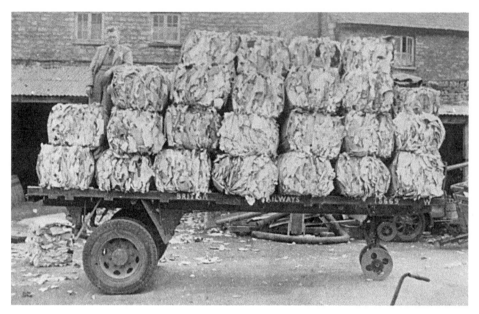

George Wilkins and the Waste Paper Collection

George Wilkins, Highways Foreman of Cirencester UDC, was one of many who organised waste paper collections. Throughout the war there was a continuous salvage campaign: waste paper was in constant demand, as were bones for making glue, explosives etc., and rabbit and moleskins. There were also book drives, where books could be passed on to service personnel or bombed-out libraries. In Cirencester Market Place there was a collecting box for recycling blunt razor blades that had collected 11,000 blades by March 1942.

Cannon at the Park Gates before the War

Metal was at a premium, so the town's cannons at the Cirencester Park gates and one outside the Barracks, captured at Sevastopol, were taken for recycling, as were many railings from outside properties. Queen Mary, who was very keen on collecting scrap, is reputed to have picked up an iron object from the roadside and taken it back to Badminton in her Daimler. A week later the farmer came to the house to ask for the return of his plough.

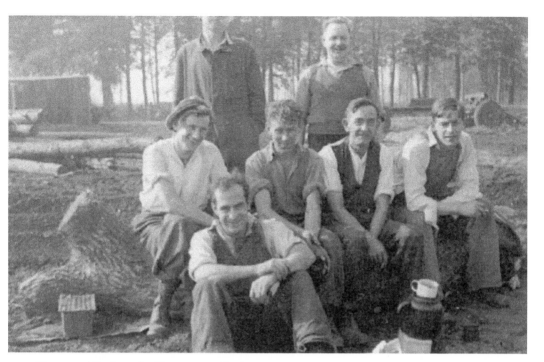

Forestry Workers in Cirencester Park
One of the essential materials needed throughout the war was timber. With importation increasingly more difficult, home production had to be exploited. These forestry workers worked in Cirencester Park, one of the local wooded areas that came into its own at this time.

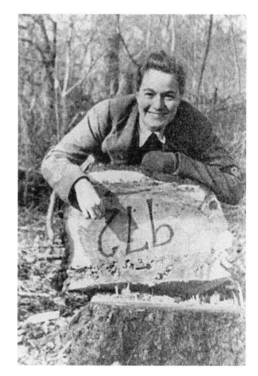

At Work in Cirencester Park
Local labour was unable to meet the excessive demand, so help had to be found. Mary Jackson was a member of the Timber Corps, the forestry branch of the Women's Land Army, who were one of the sources of extra labour in Cirencester Park.

The Bingham Hall King Street

Help came in the form of the 11th Forestry Company of the New Zealand Engineers, who arrived in Cirencester in August 1940 and set up their headquarters at the Bingham Hall in King Street. They also had huts on part of the St Michael's School field in King Street and other quarters in nearby Stonewalls, in Victoria Road. They had been en route for Europe but the events at Dunkirk intervened and they were diverted to Cirencester. Unfortunately their equipment, sent on before them, was lost in France.

Stratton House, Gloucester Road

By the end of 1940, the 11th Forestry Company headquarters had been moved to Stratton House on the Gloucester Road. The men of this company would have played a part in the defence of Cirencester in the event of invasion.

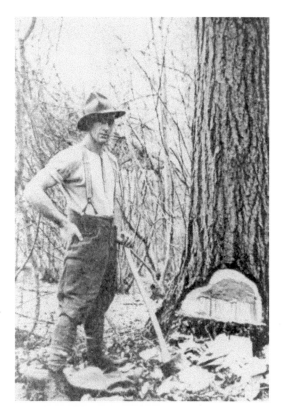

Jim McGrath Exercising His Skills on a Scots Pine

One of the first tasks was to fell beech trees for the manufacture of rifle butts to replace those left behind on the beaches of Dunkirk, but there was a need for all varieties of soft and hard woods.

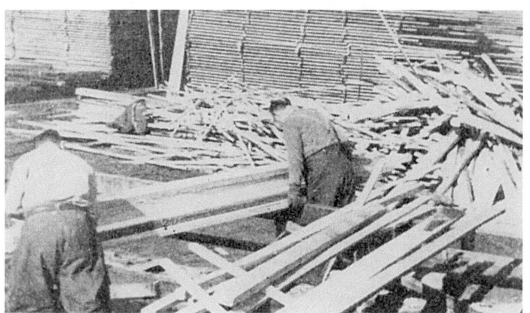

One of the Cirencester Park Saw Mills at Work

Within a short time, the 11th Forestry Company had set up permanent saw mills at Hailey Wood and Overley Wood, together with a mobile mill, which could be positioned near to the woods for lighter work. Tunnel House Inn made a useful watering hole for the foresters.

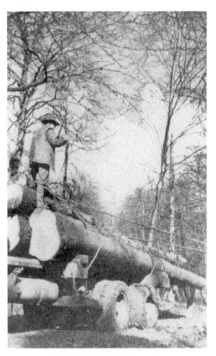

Mechanised Timber Transport in the Park

Machines were used to transport timber in Cirencester Park. There was a dispute between Captain (later Lieutenant-Colonel) Gamman, Commanding Officer of the 11th Company, and the Director-General of the State Forestry Service over methodology. The Director-General at first insisted on only horse-drawn movement of trees from felling to the mills and provided two mills in advance, which were sited in the wrong place. Captain Gamman won the day, as neither horse transport nor the original mills could cope with the volume of work.

Timber-loading Ramp at Overley Wood

The two permanent mills at Overley Wood were joined by a light railway system. One of the loading ramps along the Sapperton Road remains today.

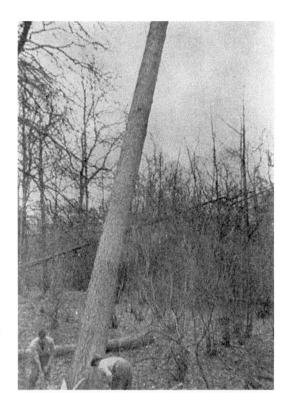

A 90-Foot Trunk About to Fall
The 90-foot trunk about to fall was to be used for planks and pit props, with the remnants producing charcoal. Eventually most of the beech was sent to Lydney plywood factory, which, among other things, supplied plywood for the construction of Mosquito aircraft. Italian prisoners of war were designated to charcoal production in Cirencester Park.

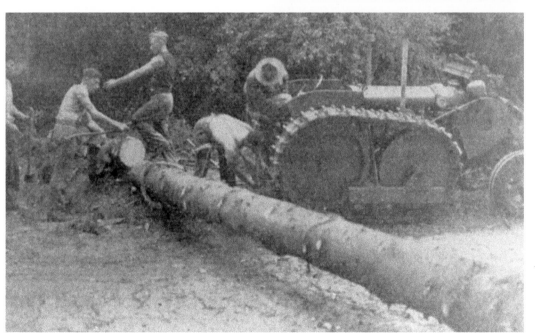

Machinery and Men Hard at Work
Lieutenant-Colonel Gamman freely admitted that the mechanised method created more mess than horse transport, but there was a war on and by the time the New Zealanders left Cirencester for the Middle East in September 1943, Cirencester Park had yielded up six million cubic feet of timber.

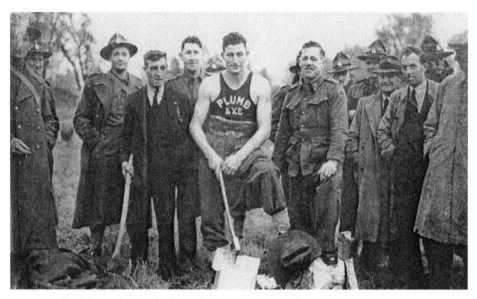

Sergeant Reg Grundy, World Log-Chopping Champion

As well as working hard and being prepared to protect the local population, the New Zealanders livened many a Saturday night. They held log-chopping competitions in the Abbey Grounds to raise funds for local charities, with the results published in the *Wilts and Gloucestershire Standard*, and world-champion Sergeant Reg Grundy, of 11th Company, became quite a celebrity. At Christmas 1940, the New Zealand Expeditionary Forces Military Dance Band, accompanied by Maori singers, performed in the Corn Hall in aid of Cirencester Memorial Hospital.

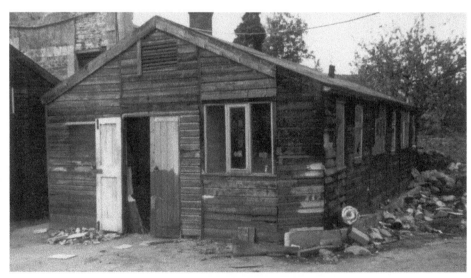

Extra Accommodation for the Church Hall British Restaurant

This wooden hut provided additional accommodation for the British Restaurant in the Church Hall. Initially the church hall provided meals for evacuees: between December 1940 and June 1942, 80,000 ration-free midday meals were served, including 220 school meals daily from October 1941. In June 1942 the hall came under the British Restaurant scheme providing 640 meals in four sittings each day between noon and 2 p.m. By the time this picture was taken, the hut was being used as a carpenter's workshop at the Cirencester UDC Depot.

British Restaurant Menu

This menu is from a booklet issued by the Cirencester Urban District Council entittled 'Community Catering in Cirencester'.

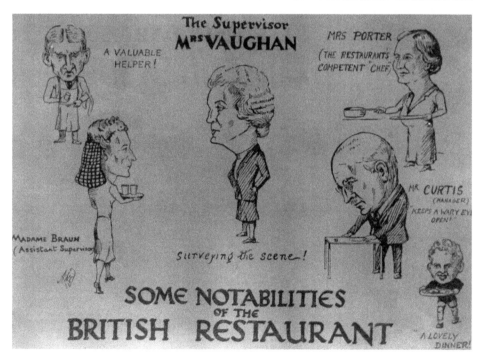

British Restaurant Cartoon, the *Standard*

This cartoon first published in the *Wilts and Gloucestershire Standard* at the time of the official opening of the British Restaurant by Sir Frederick Cripps in June 1942 and shows some of the people responsible for its success.

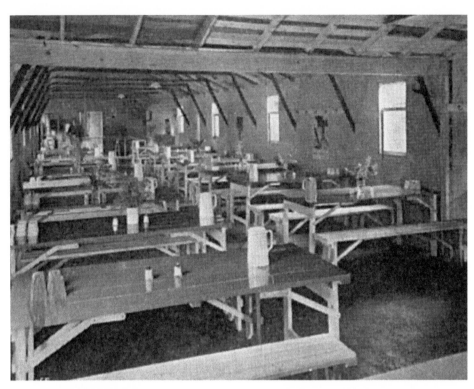

The interior of the British Restaurant in Cricklade Street showing flowers on the tables.

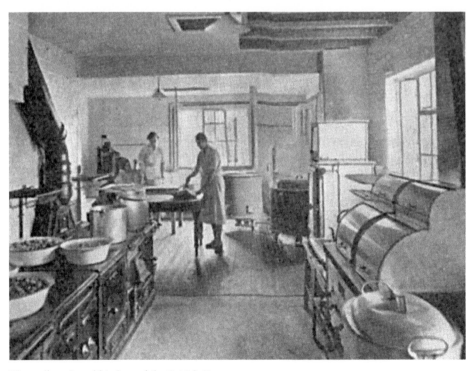

The well-equipped kitchen of the British Restaurant

Chapter 4
Lend to Defend

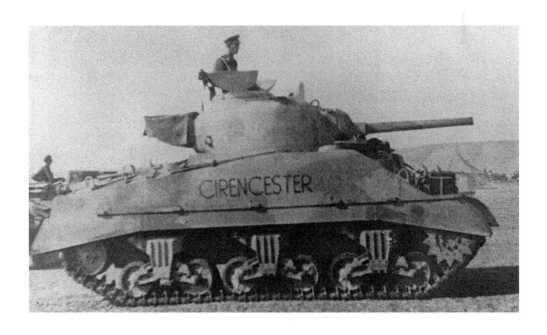

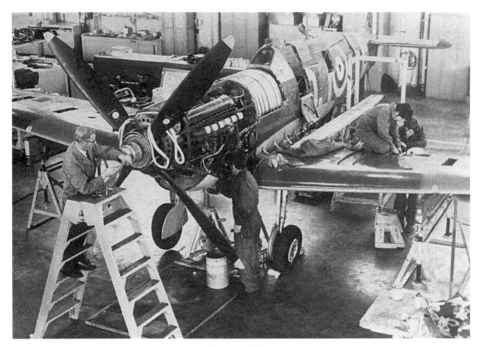

Spitfire P7350 of the Battle of Britain Memorial Flight under Restoration at Kemble in the 1960s

Many Spitfire fighters were serviced and modified at Kemble during the war, including Spitfire P7350 of the Battle of Britain Memorial Flight, which came back for restoration in the 1960s. The Spitfire Fund, where local communities endeavoured to raise the £5,000 necessary to build a Spitfire, was one of the first wartime public appeals. Unfortunately Cirencester fell short of the required amount so the authorities decided to encourage National Savings schemes instead, which gave some return to the investor.

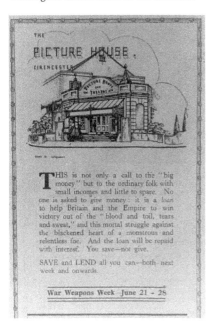

Line Drawing of the Gaumont Picture House

The Gaumont Picture House, at the junction of London Road and Victoria Road on the site of the present Bravender House, was one of various local landmarks that appeared in press as advertisements for War Weapons Week. Starting in 1941 the local National Saving's Committee, whose chairman, Captain E. T. Cripps, ran a series of week-long saving's campaigns in line with other savings committees nationally. The first was called War Weapons Week and was held in June 1941.

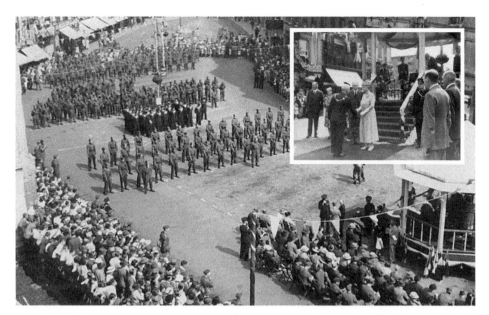

The Parade Awaiting Queen Mary's Arrival in the Market Place During War Weapons Week
Queen Mary lent her support to Cirencester's War Weapons Week. A parade was organised and awaited the Queen's arrival in the Market Place. *Inset*: Queen Mary meets town dignitaries.

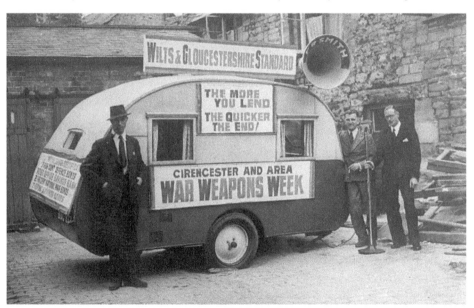

***Wilts and Gloucestershire Standard* Publicity Machine Advertising War Weapons Week with the aid of Frank Smith's Amplification Equipment**
The *Wilts and Gloucestershire Standard* Publicity caravan encouraged people to take part in War Weapons Week, with the aid of Frank Smith's amplification equipment. 'The more you lend, the quicker the end' was one of the many slogans to encourage the national savings effort; another was 'Lend to defend the right to be free.' From left to right: Tom Boulton, Frank Smith and reporter Robert Le Court.

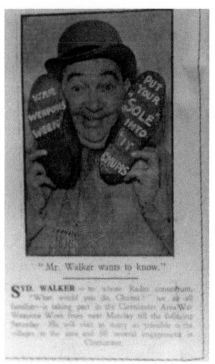

"Mr. Walker wants to know."

SYD. WALKER — to whose Radio conundrum, "What would you do, Chums?" we are all familiar—is taking part in the Cirencester Area War Weapons Week from next Monday till the following Saturday. He will visit as many as possible of the villages in the area and fill several engagements in Cirencester.

Syd Walker the Radio Junk Man

Another supporter of War Weapons Week was Syd Walker. He played a junk man on 'Mr Walker Wants to Know', part of the BBC radio show *Bandwaggon*, a favourite of all those listening to the wireless. During his stay in Cirencester, he visited various schools and institutions to drum up support for War Weapons Week.

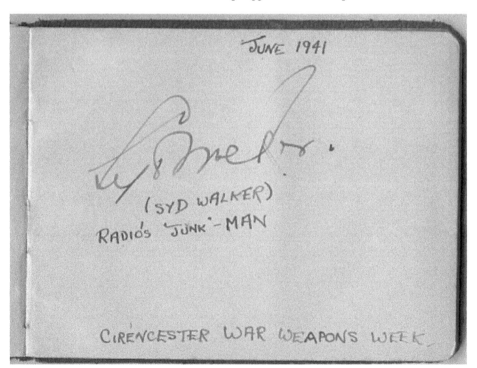

JUNE 1941

(SYD WALKER)
RADIO'S 'JUNK'-MAN

CIRENCESTER WAR WEAPONS WEEK

Syd Walkers Autograph, Collected By Local Evacuees

One of the evacuees staying in the town collected Syd Walker's autograph during his visit to Cirencester.

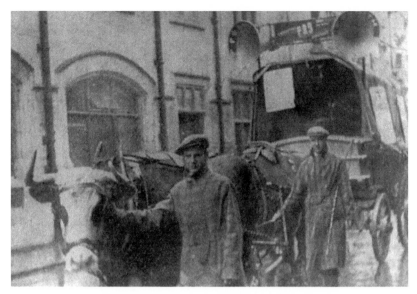

Lord Bathurst's Working Oxen in the War Weapons Week Parade

A large number of military personnel from all three services, along with the local ARP and civilian services, took part in the parades and demonstrations for the savings schemes.

During Cirencester's War Weapons Week parade, Lord Bathurst's working oxen, which had taken part in the 1930s film *King Solomon's Mines*, were used to pull a wagon in the procession surmounted by Frank Smith's public address system.

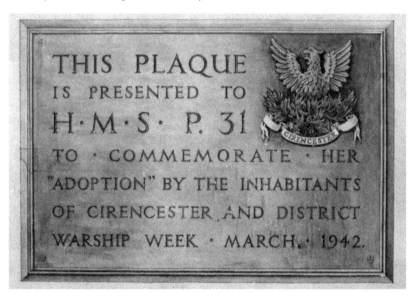

HMS *P31* Plaque

The second large savings drive was Warships Week, held from 7–14 March 1942. It worked as a sponsorship scheme in which a district could raise money to sponsor a particular class of vessel. By raising £428,000, Cirencester district was able to adopt a U-Class submarine originally designated HMS *P31*. This plaque was designed to be fixed on the *P31*, but a new plaque had to be produced when the submarine's name was changed to HMS *Ullswater*, and then to the more aggressive HMS *Uproar*.

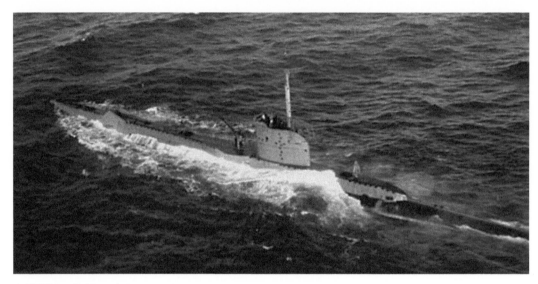

A U-Class Submarine

HMS *Uproar* was a U-Class submarine like the one pictured here. Built by Vickers Armstrong, she served first with the 5th Flotilla in 1941, and was commanded by Lieutenant Commander J. B. Kershaw DSO. She was transferred shortly after to the 9th Flotilla, taking part in action against the German battleships *Bismarck* and *Prinz Eugen*. Most of her service was in the Mediterranean around Malta in 1943–44 under a new commander, Commander Lieutenant L. E. Herrick. She was based mainly in Alexandria and received battle honours for her action around Sicily. Despite severe damage in action during her career, HMS *Uproar* survived the war and was placed on reserve in 1945.

The CRE Building in Thomas Street

The Commander Royal Engineers department (CRE) was an agency for looking after the building and architectural needs of the local military camps, and was in Thomas Street. One of those employed there as an architect was Dom Mintoff, who later became the Prime Minister of Malta and, ironically, closed the British naval facilities on the island.

**Crew Members on the Bridge of HMS
*Uproar***

After Warships Week, the townsfolk kept
contact with the crew of HMS *Uproar*,
sending books and small gifts. One former
member of the crew remembered with
affection that they received garments
from the various knitting circles in town.
However, he said that from the shape of
the garment it was sometimes impossible to
work out which part of the anatomy it was
intended to cover.

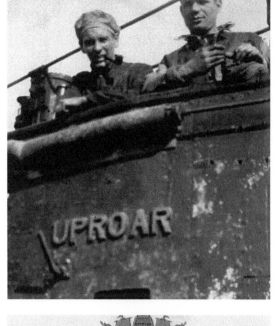

**Poulton Village's War Weapons
Week Certificate**

The Cirencester savings district covered a
number of nearby villages. Poulton, like
the others, received a certificate from the
admiralty acknowledging its contribution
towards the adoption of HMS *P31*. On
16 August, Poulton had received an
unwanted donation of 400 anti-personnel
bombs and thirty-four high-explosive
bombs. Maybe the German bombers were
aiming for the Air Freight Control Centre,
known as 'the Piggeries' – a military
communications centre between Poulton
and Down Ampney.

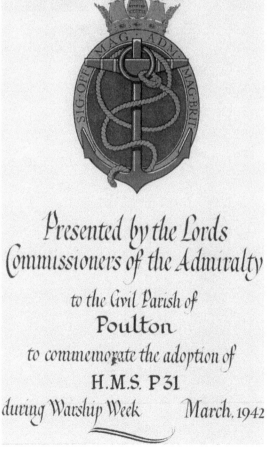

Presented by the Lords
Commissioners of the Admiralty
to the Civil Parish of
Poulton
to commemorate the adoption of
H.M.S. P31
during Warship Week March, 1942

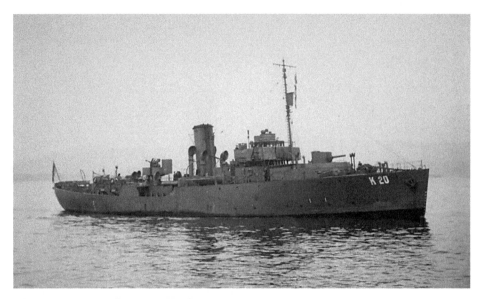

The Flower-Class Corvette HMS *Starwort*

Northleach district raised sufficient funds to sponsor a Flower-class Corvette escort vessel, HMS *Starwort*. *Starwort* served with distinction, surviving the war to become a merchant vessel. During wartime service she was responsible, along with HMS *Lotus*, for the destruction of the German Submarine *U-660* in an action off Oran in the Mediterranean.

Cirencester Sea Cadets

Despite Cirencester being around 60 miles from the sea, a considerable number of local men and women served in the Royal Navy and Merchant Navy – many received their initial training in the local Sea Cadets, commanded by Lieutenant Belcher. Their 'deck' was above Farrell's shop on the south side of Castle Street. They had a successful drum and fife band and by 1944 had sent twenty-five of their cadets into the British naval forces.

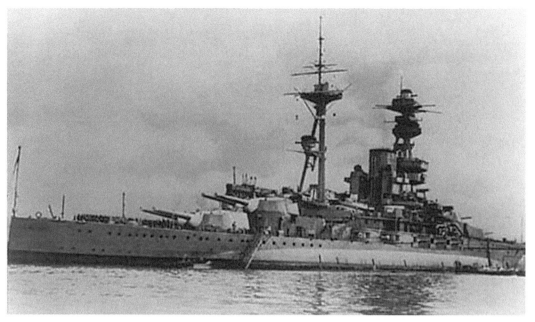

HMS *Royal Oak*

Some of Cirencester's earliest war casualties were two sailors killed when HMS *Royal Oak* was sunk on 14 October 1939. They were Ordinary Seaman Geoffrey Ronald Pollard, aged seventeen, and Leading Seaman Edward Benjamin Warriner, aged twenty-nine. At one time, a memorial seat dedicated to them was situated by the scout hut in Cotswold Avenue.

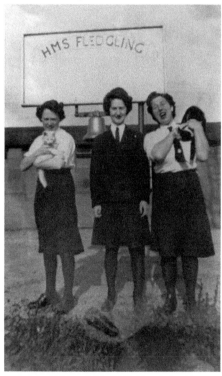

Miss Goody (far right) at HMS *Fledgling*

Cirencester resident Iris Goody was a member of the WRNS from 1942 to 1946 and gained the rank of Petty Officer. She served at the naval establishments HMS *Pembroke, Beehive, Midge, Beaver, Fledgling, President* and the Royal Naval College Greenwich. On her return to Cirencester after the war she took up a lengthy career in charge of providing school meals to generations of pupils at Cirencester Grammar School.

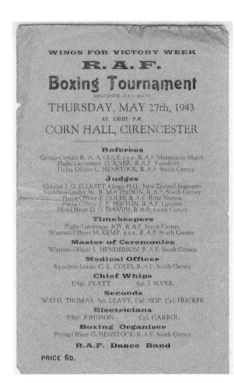

Corn Hall Boxing Tournament Programme

May 1943 saw Wings for Victory Week, when the Cirencester savers went all out to raise money to sponsor a number of different types of aircraft. The usual parades, processions and demonstrations were held. An extra for this campaign was a boxing tournament organised by the local RAF stations in the Corn Hall on 17 May 1943. The contestants on the programme that evening included World and British Empire light-heavyweight champion Sergeant Freddie Mills and British Empire featherweight champion Sergeant Nel Tarleton, who were both serving in the RAF.

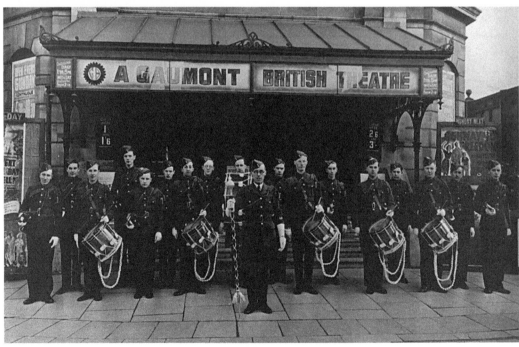

ATC Band on the Steps of the Gaumont, February 1943

Since the RAF had such a prominence in the area, there were strong local contingents of the Air Training Corps in Cirencester and Fairford. Cirencester's ATC Band took a prominent part in many civic activities such as Wings for Victory.

Cirencester's Salute the Soldier Week Plaque
Salute the Soldier Week in May 1944 raised money to
support the soldiers of Britain, who were preparing for
the invasion of Europe less than a month later.

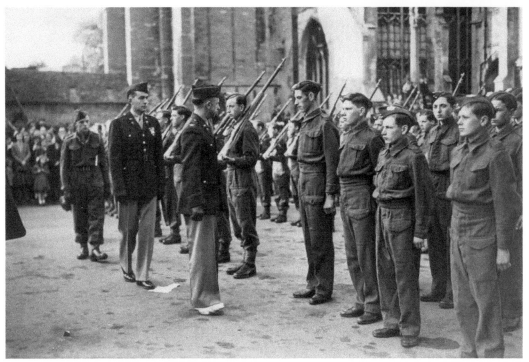

Cadets from Cirencester Grammar School and the Town's Army Cadet Force
Cadets from Cirencester Grammar School and the town's Army Cadet Force on parade. The inspecting
officers are Commanding Officer Colonel O. H. Stanley, with his foot in plaster, and Colonel Louis Orr
of the US 15th Hospital Center.

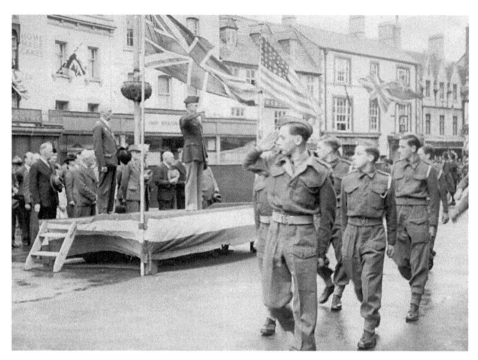

Army Cadets, Salute the Soldier Parade
Colonel Stanley took the salute in Cirencester Market Place as the army cadets marched past during the Salute the Soldier Youth Day Parade at 7.30 p.m. on Thursday 11 May.

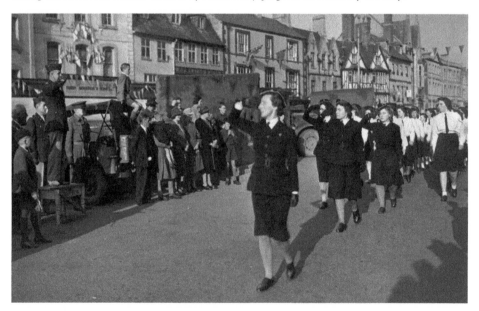

Cirencester Girls Training Corps on Parade
The Cirencester Girls Training Corps had a very strong contingent in the Youth Day Parade. The corps was started in 1942 to train girls before they went into the services. There was a considerable emphasis on citizenship and members were trained in such diverse subjects as firefighting and sex education. Those wanting a less formal set-up could join the Girls' Club.

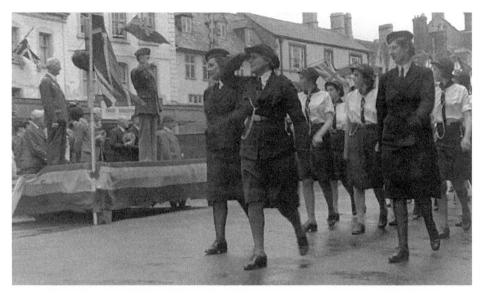

The Cirencester Rangers on Parade
The Rangers provided personnel for all three forces, mainly the WRNS and nursing services. During the Youth Day Parade, Divisional Commissioner Mrs Herbert led the Rangers past the saluting base.

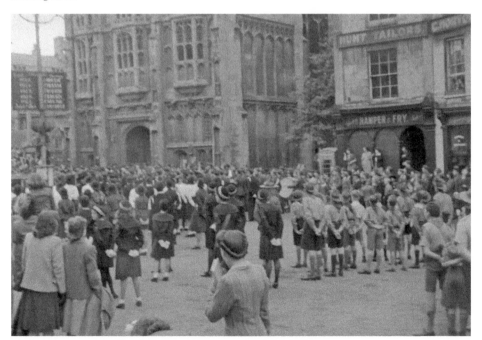

More of Cirencester's Youth Organisations on Parade
There were a number of other contingents on parade, including the Scouts and Cubs, Girl Guides and Brownies and the Girls Life Brigade. Among the Scouts were the Brotherhood of British Scouts, who separated from the Baden-Powell movement in 1912. At the time of the war, its chief commissioner was Percy Pooley, who came to Cirencester in the 1930s to work at Rendcomb College and was the mainstay of the BBS until his death in 1971.

Stratton Brownies, 1942

Many of the evacuees joined local youth groups. These girls were Brownies in Stratton in 1942. As well as supporting the various savings campaigns, the young people of the town were heavily involved in salvage and horticultural activities, as well as taking part in the many ARP and Home Guard exercises as casualties or messengers. Everyone was expected to take part in some organisation and many cadets went into the branch of the services they were partially trained for.

Cirencester's Small Savers Tank in the Middle East

As well as the major savings campaigns there was a constant call for people to save with savings organisers in streets, factories and schools with a number of incentives offered as encouragement. One scheme was Tanks for Attack. Small savers who increased their amount by at least 20 per cent over the previous year could have the name of their district painted on a tank, 20 per cent on a light tank, 25 per cent for a medium tank and 30 percent for a heavy tank. Cirencester's savers raised enough for the town's name to be painted on this Sherman Tank, which is seen with the Royal Gloucestershire Hussars in the Middle East.

Chapter 5
Making Do

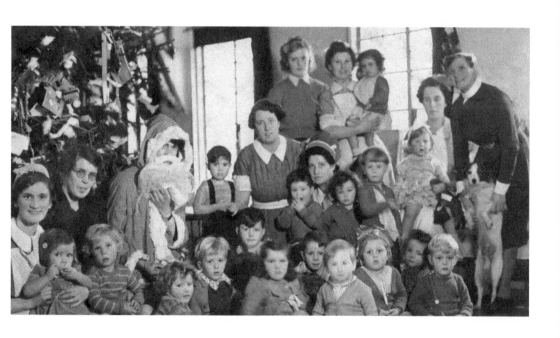

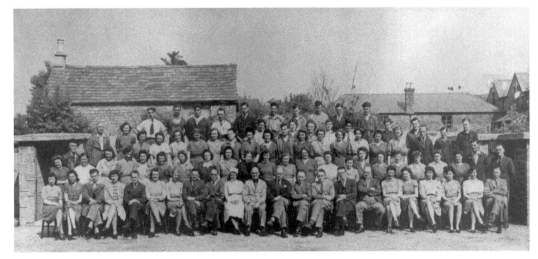

The Staff of the Dulci Factory Outside the Air-Raid Shelter in the Regal Cinema Car Park
To disperse production of war materials to safe areas, 'shadow' factories were located in empty or requisitioned premises in towns like Cirencester. The Dulci factory manufactured weapon components in Steel's garage premises in Lewis Lane, the Lewis Lane waterworks and the former electricity generating station in Barton Lane, and they used Beeches House for their offices. They shared the Regal car park air-raid shelters with the Council School.

Dyer Street Entrance to Steel's
As well as housing, the Dulci factory – Steel's Garage, which had an entrance in Dyer Street – also contained a shopping facility where war workers on difficult shifts could obtain essential supplies outside normal shopping hours.

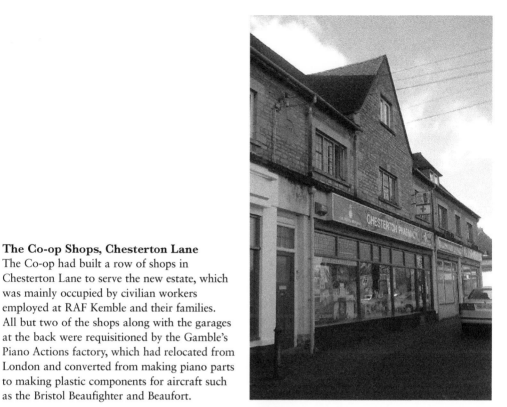

The Co-op Shops, Chesterton Lane

The Co-op had built a row of shops in
Chesterton Lane to serve the new estate, which
was mainly occupied by civilian workers
employed at RAF Kemble and their families.
All but two of the shops along with the garages
at the back were requisitioned by the Gamble's
Piano Actions factory, which had relocated from
London and converted from making piano parts
to making plastic components for aircraft such
as the Bristol Beaufighter and Beaufort.

The Site of GPA Brewery Buildings, off Cricklade Street

The GPA factory also occupied part of the old
brewery buildings off Cricklade Street, where
they converted their piano-making skills to
produce the tail sections of Lancaster Bombers.

Site of Cricklade Street Factory Units
A row of newly built shop units at the top of Cricklade Street, opposite Woolworths, were unoccupied in 1939 and so the shop windows were boarded up with plywood to form a series of small factory units. One housed a heating and moulding apparatus for moulding the cockpit canopies of Spitfire fighters. Tovey's local heating engineers were responsible for its maintenance.

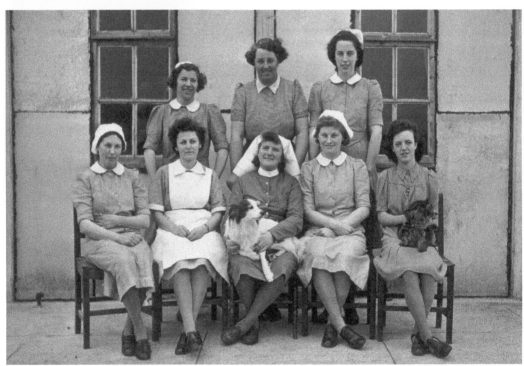

The Staff of the Abbey Way Nursery
A state-run infant's nursery was set up in prefabricated buildings on Abbey Way to encourage young mothers, particularly the mothers of evacuees, to take up war work in the Cricklade Street units and elsewhere in town. From left to right, front row: 'Nanny' Rose Lock, Sister Liz Frost, matron Mrs Mayman, nurse Evelyn Norfolk and assistant Mary Dike. Back row: Nurse Kath Adlington née Peden, nursery teacher Margaret Watson and nurse Marie Parsloe.

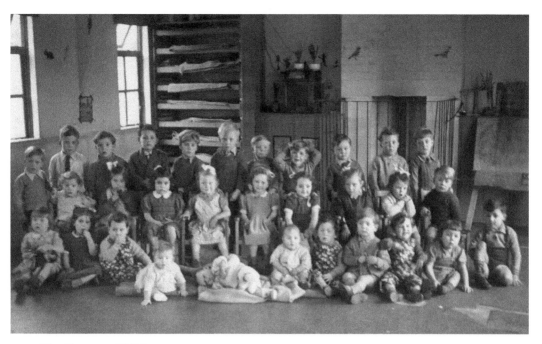

The Nursery Children
Conditions in the classroom reflect the austerity prevailing at the time. However the children look happy despite the lack of play equipment.

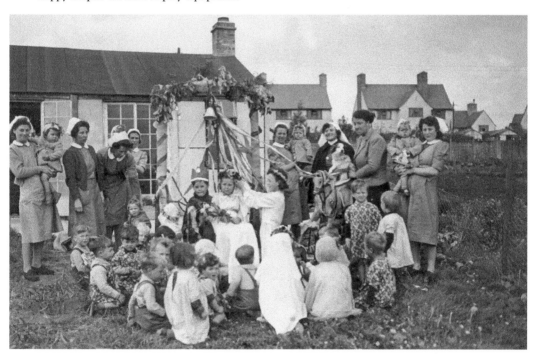

May Day at the Abbey Way Nursery
Despite the restrictions of the time, the staff at the Abbey Way nursery endeavoured to maintain traditional activities. On May Day, the children dressed up and had a May Queen and maypole.

Father Christmas at the Nursery in 1944
The children at Abbey Way nursery are celebrating Christmas in 1944 and, even in wartime, Father Christmas managed to visit. Similar activities took place at the other state-run nursery, which had been set up on Chesterton estate, off Apsley Road.

Cecily Hill House and Cecily Hill
The large Georgian building in the foreground is Cecily Hill House, which was requisitioned as the headquarters of the Texas Oil Company when it relocated from London. Beyond this are the Dolphin Inn and the Barracks. The other three-story building below the barracks was loaned by the Bathurst family to house young evacuees suffering from the trauma of separation from home. It was also used by one of the sections of 'C' Company of the Home Guard as their section headquarters.

The Friends' Meeting House, Thomas Street

With no Quaker meetings in Cirencester at the beginning of the war, the Friends Meeting House in Thomas Street was used as the National Service Office, where citizens signed on for civil or military service. It was used as a meeting house again, alongside the government's use in 1946, when Dr Edgar Hope Simpson, a Quaker, set up a general practice in town. He also worked as medical officer to the German prisoner-of-war camp at Siddington until it closed in 1948.

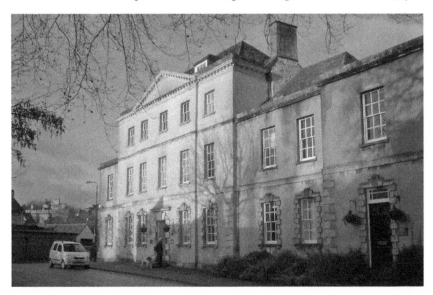

Mead House, Thomas Street

Mead House lies almost opposite the Friends' Meeting House in Thomas Street, at the junction with the Mead. During the war, it was the home of the Cripps family. The basement of this building was strengthened so that it could be used as an emergency air-raid shelter by the pupils of Powell's School, who reached the house by crossing the river on a footbridge at the side of the Temperance Hall.

Park House in Dollar Street

The basement of Park House, Dollar Street, was also strengthened to make a shelter for more of Powell's pupils. In 1943, Mr Runacres, the manager of the Texas Oil Company, set up the War Workers Recreation Centre here, as a social centre for the many workers who had come into the district. An orchestra was based there, as well as a theatre group and other recreational outlets. Mr Runacres also organised many of the dances and other entertainments in the Corn Hall.

HOLY TRINITY, WATERMOOR

LENT LANTERN SERVICES
"The Men who Crucified Christ"
Wednesday, April 7th
at 7.30 p.m.
Subject : " PILATE "

G.P.A. LTD.
— PRESENT —
(in conjunction with Cirencester
Workers' Welfare Centre)
GRAND
Cabaret Dance
— AT THE —
CORN HALL,
CIRENCESTER,
SATURDAY, APRIL 10
Dancing 7.30 p.m.

Norman Brooks
(B.B.C. FAME) and
HIS BALLROOM ORCHESTRA
Supported by the following B.B.C.
and Music Hall Artists :
BENNETT and WILLIAMS
Phono Fiddle Boys.
PETER WILLIAMS
B.B.C. Vocalist (late Billy Cotton)
TONY and TALBOT
Partners in Fun.
LES GROVES
Compere and Entertainer.

Admission 4/- Limited Number
of Tickets ob-
tainable from G.P.A. Office Chesterton Lane
or Cricklade Street, Cirencester.
Light Refreshments available.

BEAUFORT HUNT PONY CLUB

GPA Dance Advert from the *Standard*

In 1943, GPA Ltd organised a dance at the Corn Hall and advertised the event in the *Wilts and Gloucestershire Standard*. This was one of many social events and there were often visiting bands such as the RAF broadcasting cabaret band led by Felix King, who had been pianist to Florence Desmond, a popular singer of the day. The band included Teddy White of Roy Fox's Band, Harry Baler of the Ambrose Band and Max Lewin of Geralodo's orchestra. There was also a wealth of local talent, including Alec Mattock and his band and the dance band from RAF Kemble featuring 'Razzle' Reeves on piano.

Make Do and Mend Leaflet

Another feature of the middle years of the war was the call to 'make do and mend'. Repairing clothes, shoes and domestic appliances was encouraged along with recycling. Parachute silk was much prized for the making of underwear. At Christmas even the fortnightly egg could be blown carefully, painted and covered with glitter to hang on the tree.

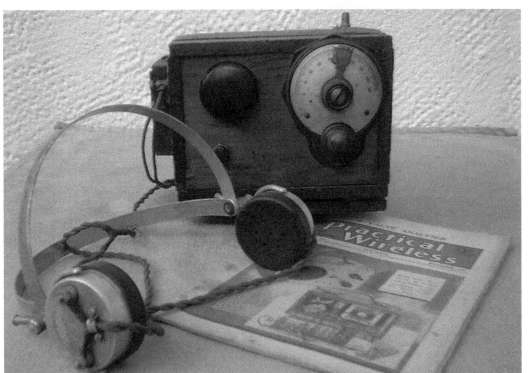

Homemade Radio

Some local people undertook more substantial projects such as constructing a single-valve radio from plans in the *Practical Wireless* in order to compensate for shortage of supplies.

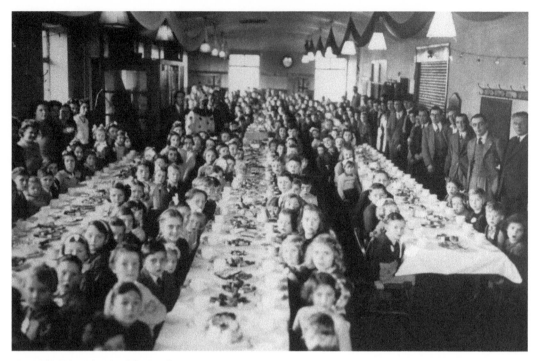

Kemble Party in the Works Canteen in 1942/43

A Christmas party in the works canteen Kemble in 1942 or 1943. New toys were early victims of the war and many parents had to resort to producing homemade playthings. The civilian workers at RAF Kemble spent much of their limited break-time recycling materials to make toys for distribution at the annual Christmas party. Wooden wheels for toy trucks and trains were turned on the lathes and the plywood packing cases of Horsa gliders made excellent wooden farm animals using patterns from the *Hobbies* magazine.

Toy Windmill Made by George Grace, the Author's Father

This toy windmill was made by George Grace from recycled plywood painted with grey undercoat sprinkled with redundant canary sand to give a stone effect. The metal window frames with their ridged glass were from blackout light-restrictors from lorry headlamps. The domed roof was of recycled aluminium and the slow-geared motor beneath came from the landing-light adjustment system of a Lancaster bomber. Even the transformer was homemade.

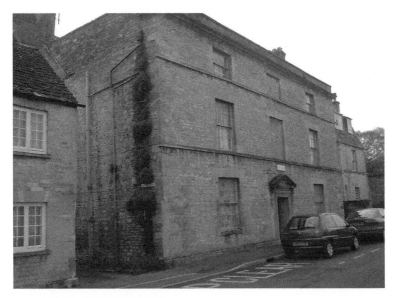

Querns Lane House, Querns Lane

Querns Lane House in Querns Lane became a clothing exchange and repair depot in 1939, as clothing for evacuees and other needy children was a constant problem. In 1940, it moved to the Old Grammar School in Park Lane then in 1942 it combined with the Rural District Depot and operated from the Corn Hall. Hundreds of knitted items were also made, mainly for the forces, by the various knitting circles in the area, including Lady Bathurst's very prolific one at The Mansion.

The Sheep Street Bandaging Centre

Various premises around the town operated as Red Cross centres for the production of bandages. The bandaging centre at Kingsleigh in Sheep Street was captured in this sketch by Mrs Boutflour, the wife of the Principal of the Royal Agricultural College. She was an accomplished artist and, like many others, gave freely of her time to help the Red Cross war effort. The County Surgical Supply depot over the Market Place Premises of Boots chemists received a royal visit from Queen Mary earlier in April 1940.

Chapter 6
Towards the End and Beyond

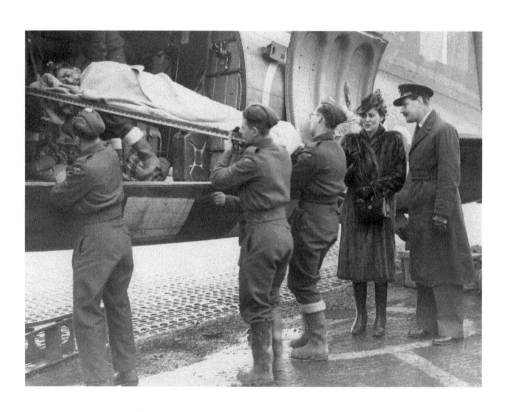

Local Airfield Map

As the war progressed many military establishments appeared in and around Cirencester. RAF bases were predominant, mainly providing additional facilities for Aston Down, Kemble and South Cerney. In 1943, despite the fact that enemy invasion was still a possibility, construction work began on major bases for the planned allied invasion of Europe. These were at Blake Hill Farm near Cricklade, Down Ampney and Fairford. At Southmead, off Siddington Road, a labour camp was established for the construction workers, the majority of whom were Irish.

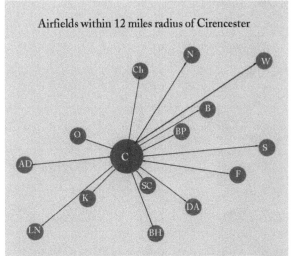

Airfields within 12 miles radius of Cirencester

AD- Aston Down, B- Bibury, BH- Blake Hill, BP- Barnsley Park, C- Cirencester, Ch- Chedworth, DA- DownAmpney, F- Fairford, K- Kemble, LN- Long Newnton, N- Northleach, O- Overley Wood, S- Southrop, SC- South Cerney, W- Windrush

RAF South Cerney Medical Service Personnel

Medical service personnel at RAF South Cerney. As the focus changed from defensive action to the possibility of offensive action, pilot training at South Cerney was stepped up. This led to an increase in flying accidents in the area putting extra strain on the camp's medical staff.

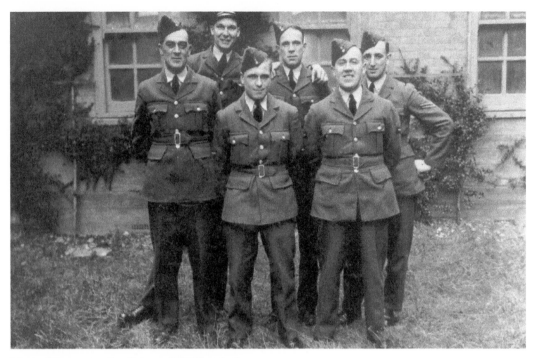

Motor Transport Staff from RAF South Cerney

At RAF South Cerney, the motor transport section's ambulance was kept busy retrieving aircrew who had been unsuccessful at taking off or landing during training in aeroplanes such as Airspeed Oxfords and Harvards.

NAAFI Photo of Mrs Nellie Darlow

Increased activity on the bases meant more work for other unsung heroes, such as the NAAFI personnel, who tried to meet the needs of the forces. Mrs Nellie Darlow was one of the NAAFI employees from the RAF South Cerney group who were awarded the Silver Challenge Cup for excellence in 1943.

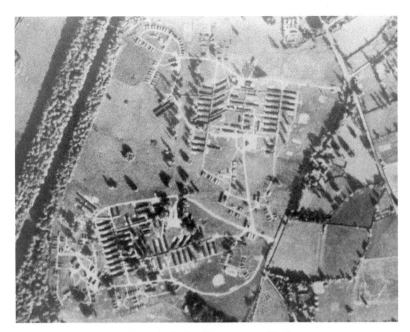

Aerial view of US Military Hospitals in Cirencester Park

In 1943, a number of large military hospitals for the United States forces were built in the area, including two in Cirencester Park: the 188th and 192nd General Hospitals shown in this aerial view. The entrance to the 188th was on the Stroud Road and the 192nd was entered from the road leading to the cricket field on land now occupied by the Deer Park School and Cirencester College.

The 15th Hospital US Center Motor Pool on St Michael's Field

There were US Rangers in Fairford as early as 1942. In March 1944 the first medical group who arrived were the personnel of the 15th Hospital Center. This was the administrative hub of a group of fourteen US hospitals and convalescent facilities around Cirencester and further afield, from Ullenwood, near Cheltenham, to Rotherfield, north of Reading and the Churchill Hospital in Oxford.. The 15th Hospital Center was based first at the Bingham Hall and The Shrubbery next to the grammar school, with the motor pool on part of St Michael's School field.

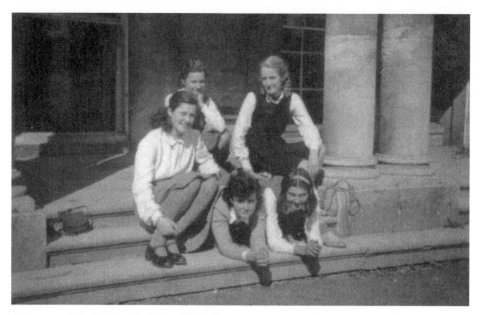

A Group of St Michael's School Pupils
St Michael's School occupied Watermoor House and was run by the Anglican nuns of the order of the Sisterhood of the Holy and Undivided Trinity. These girls were photographed in 1947 but would have been pupils at the school at the latter end of the war, at which time there was, of course, no fraternising allowed between pupils and the servicemen using the motor pool on the school field.

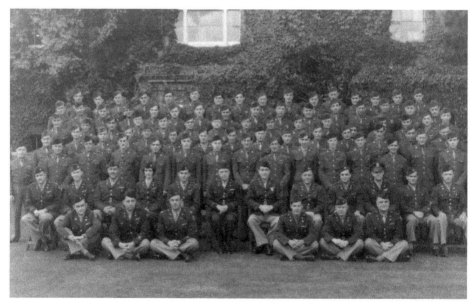

Enlisted Men and Officers of the 15th US Hospital Center
Two months after arriving from Texas, the staff of the US 15th Hospital Center moved to Stratton House, which had been vacated by the 11th Company of the New Zealand Engineers. However, the motor pool stayed at St Michael's and The Shrubbery was used as accommodation for American Red Cross personnel.

US Military Police 'Snowdrops' outside the Entrance to the 192nd General Hospital
A US Military Police unit was stationed in premises halfway down the east side of Cricklade Street.
The men, known as 'snowdrops', are seen here outside the entrance to the 192nd General Hospital.
The US forces also set up a storage depot in the requisitioned Grove Garage in the Market Place.

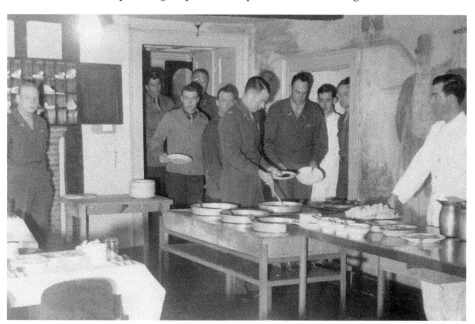

The Officer's Mess at Stratton House
The 15th US Hospital Center staff at the officers' mess at Stratton House. Commanded by
Colonel Oramel Stanley, the center oversaw all aspects of organisation and staffing within its
assigned hospitals. In addition to those already mentioned, the hospitals in the Cirencester area
were the 111th, at Daglingworth on Gloucester Road; 160th at Stowell Park; 186th at Fairford;
61st at Broadwell; 317th at Charlbury and 327th at Moreton-in-Marsh.

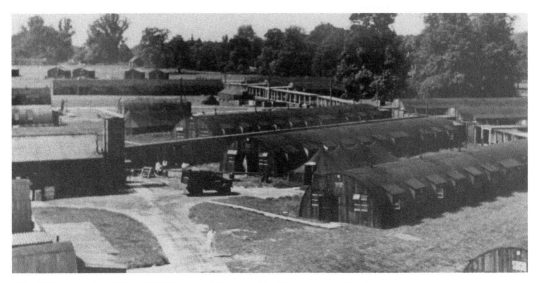

Ward Huts at the 192nd US General Hospital in Cirencester Park
These ward huts at the 192nd US General Hospital in Cirencester Park were typical of those found in all the US hospitals. This hospital and the nearby 188th had 1,000 beds, with all the departments found in any major hospital. They provided the latest techniques, from counselling to major surgery. All the hospitals were ready before D-Day, 6 June 1944, which marked the beginning of Operation Overlord, the invasion of Europe.

The Operating Theatre of the 192nd US General Hospital
As the first casualties arrived from D-Day, the operating theatres – such as this one at the 192nd US General Hospital – began their long and distinguished careers.

Post-Operative Care
Tens of thousands of casualties passed through the local hospitals before the war ended.

Unloading Casualties at the 192nd Hospital
The ambulance vehicles brought the casualties to the hospitals from the railheads at Shrivenham and Watermoor and the local airfields. Each special ambulance train carried at least 108 stretcher cases. German casualties were dealt with at the 188th Hospital in Cirencester Park.

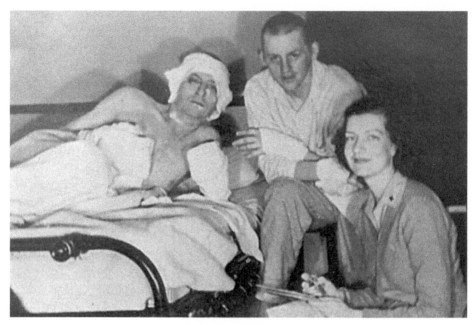

A US Red Cross Worker at the 192nd Hospital Helps with Writing Home
As well as the huge staff of nurses and orderlies, there were American Red Cross workers on hand to help with the more personal needs, such as writing home. Many of them were quartered in The Shrubbery in Victoria Road and, not being used to the English weather, they frequently overloaded the electricity system by keeping electric fires on all the time.

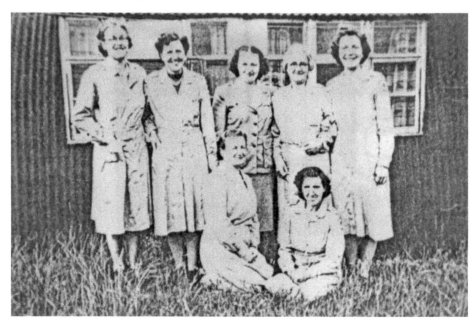

Local Red Cross Workers Who Visited the Hospitals
This group from Cirencester's Red Cross detachment helped in many ways at the hospital, with the library trolley and writing letters for patients. They also helped to run a service canteen at the Congregational Church Rooms.

The Linen Supply Lorry at the 192nd Hospital
Cecil Sands was responsible for the vital supply of
linen to the 192nd Hospital. German prisoners of war
looked after many of the less savoury duties. One of
the greatest difficulties at the 192nd and 188th was the
maintenance of the drainage and sewer system.

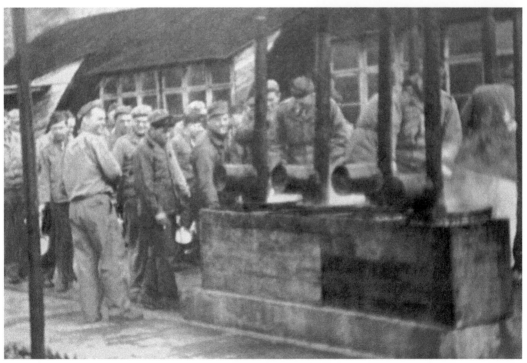

Enlisted Men's Mess Queue at the 192nd Hospital
Feeding the large number of medical staff and patients was a vast logistical problem and large mess
halls were required. This is the enlisted men's mess queue at the 192nd Hospital. There were covered
walkways between huts to help with the transport of food and medicines throughout the hospitals.

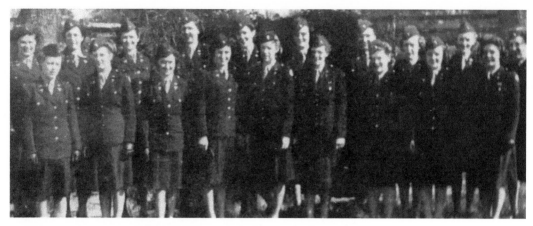

Section of Female Nursing from the 192nd US General Hospital
These nurses from the 192nd US General Hospital are just a few of the hundreds of nurses who brought comfort to the sick and wounded returning from the battlefields of Europe. All the latest equipment was available within the hospitals, including up-to-date X-ray and physiotherapy equipment.

Major Dwight Harken, One of the Surgeons at the 160th Hospital, Stowell Park
Major Dwight Harken was typical of the calibre of surgeons and doctors at work in the area. While serving at the 160th at Stowell Park, he perfected techniques for dealing with bullet and shrapnel wounds to vital organs that still form the basis of those used today in the United States and other advanced medical centres.

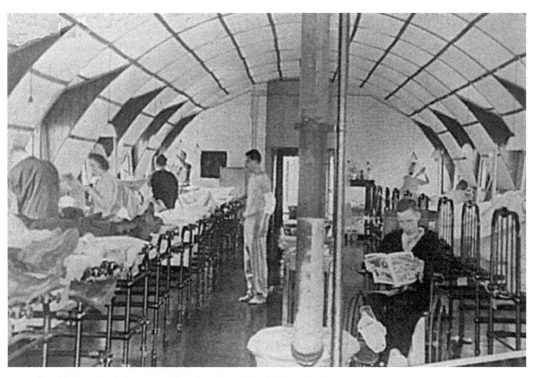

An Abdominal Surgery Ward at the 192nd Hospital
Major Harken was also the first man to successfully undertake open-heart surgery and he invented the first artificial heart valve. His regimes for recovery from post-thoracic surgery still feature in modern US military medical manuals. Another of his colleagues at Stowell Park, Dr Zoll, pioneered the heart pacemaker and the defibrillator.

The Laboratory Facilities at the 192nd Hospital
Staff in the laboratory facilities at the 192nd Hospital. Among many distinguished visitors to the hospitals of the 15th Center was Sir Alexander Flemming, the pioneer of penicillin, which saved the lives of many of the patients.

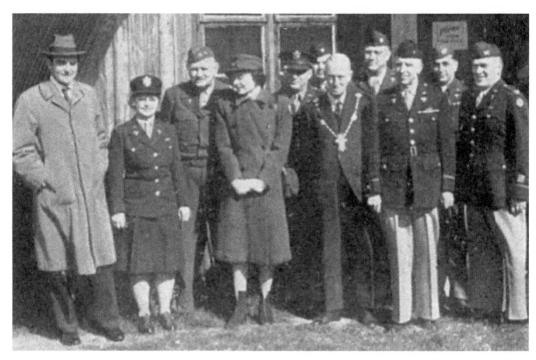

Dignitaries visiting the 192nd hospital
US Ambassador to Britain Mr Wynant, far left, visited the 192nd Hospital on 21 March 1945 with high-ranking officers from the European theatre of war. Others to visit included Queen Mary, the Duchess of Kent and Sir Stafford Cripps who lectured on post-war politics.

Captain Glenn Miller (right)

Captain Glenn Miller and the band of the AEF playing to the staff and patients in Cirencester Park

On 7 August 1944, Captain (later Major) Glenn Miller and the band of the American Expeditionary Force (AEF) came to play to the staff and patients of the military hospitals in Cirencester Park. A few weeks earlier on D-Day, Captain Darcy and the American Army Band gave a very successful concert in Cirencester Market Place.

Dancing to the Glenn Miller Band in Cirencester Park

Glenn Miller and his band were transported to and from Cirencester by Dakota aircraft, landing at RAF South Cerney. They played two concerts during the day and toured the wards in small groups. In the evening, local people were able to dance in Cirencester Park to music by perhaps the most famous band of the day. During his small amount of free time, Captain Miller rested at The Shrubbery in Victoria Road.

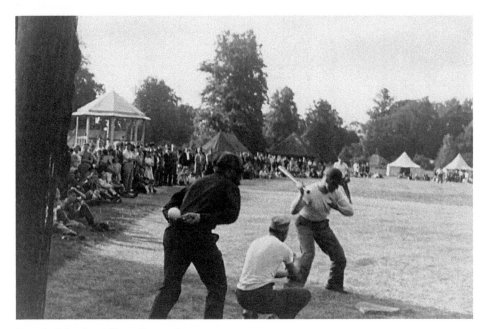

Baseball in the Abbey Grounds
Like the New Zealand troops, the American servicemen brought their favourite sport with them.
The Abbey Grounds were the venue for this game of baseball.

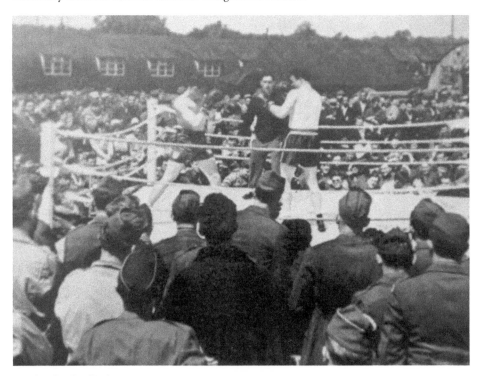

Boxing in the Park
Boxing was popular and this ring was set up in Cirencester Park. The Americans also ran a
successful basketball league between the hospitals assigned to the 15th Center.

King Street in 1944

In this view of King Street in 1944, US vehicles can be seen in the background outside the Bingham Hall, which was retained by the US military as an Other-ranks club known as the Doughnut Dugout. The doughnuts manufactured here were distributed around the US establishments, mainly by vehicles garaged in the former stable mews at The Mansion in Park Street. The US officers club was established at No. 38 Castle Street.

US Troops Fraternising with the Locals

There was considerable fraternisation between the American troops and the local population. However, Mary Wolfard, an inspector on the railway at Cirencester who helped at a war workers' club, recalled how an American Officer called to say that his men would attend the dances. He explained that there was the problem because the white and black troops could not mix. At that she replied, 'Okay we'll take black', which they did and there was never any trouble. Evidently the locals didn't understand race prejudice.

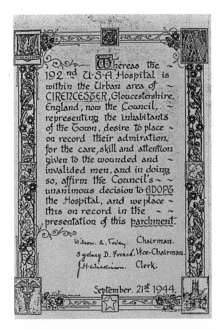

The Illuminated Manuscript Announcing Cirencester's Adoption of the US Hospitals Within its Boundaries

On 21 September 1944, Cirencester adopted the 15th Center and the hospitals within its urban boundaries. An illuminated manuscript, created by Mr Flexen of the grammar school, was presented to their commanding officers to mark the occasion. A similar ceremony was performed by the Rural Council.

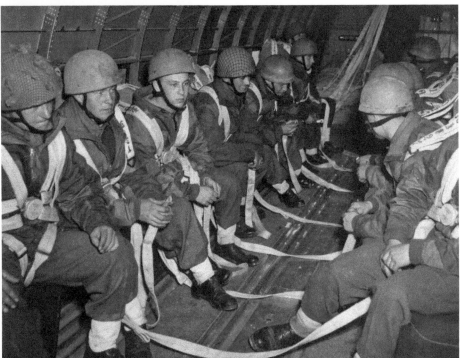

Parachutist in Training over the Cotswolds

Long before D-Day, the new airfields at Blake Hill, Down Ampney and Broadwell, of 46 Group Transport Command, and Fairford, of 38 Group Transport Command, were heavily involved in the training of parachute troops and glider-towing operations in preparation for the invasion. In one incident early in 1944, a glider crashed and thirty men had to be brought to the Cirencester Memorial Hospital for treatment.

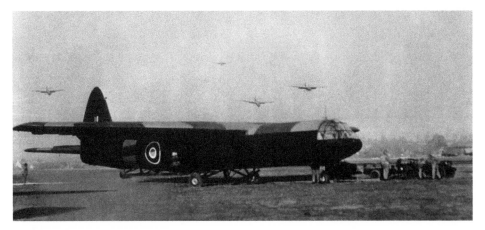

A Horsa Glider Lands in France
The Horsa gliders from Blake Hill, Down Ampney and Fairford were among the first to land in France. Many of them used on D-Day and later for the Arnhem operation were assembled at RAF Kemble. The glider sections came in large wooden crates, which provided short-term accommodation for service personnel at RAF Kemble.

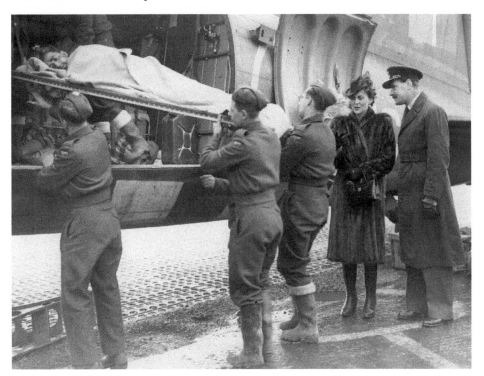

The Duchess of Kent Witnesses the Arrival of Casualties at Down Ampney in December 1944
Within hours of the first airstrips becoming available in France, Dakotas from the local bases were returning with the wounded. Often they came straight from the clearing stations to the Casualty Air Evacuation Unit Hospitals at Down Ampney and Blake Hill. German casualties went from the hospitals to captivity. In December 1944, the Duchess of Kent witnessed the arrival of casualties at Down Ampney.

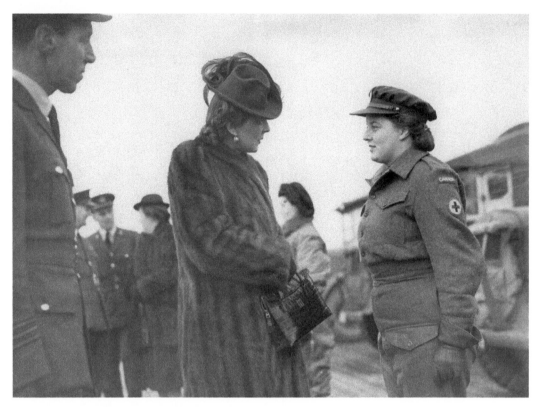

The Duchess of Kent Speaking with a Canadian Ambulance Driver at Down Ampney
The Duchess of Kent spoke with troops, including this Canadian Ambulance driver, at Down Ampney. Fleets of ambulances and the rail system were used to take casualties to specialist hospitals as soon as possible.

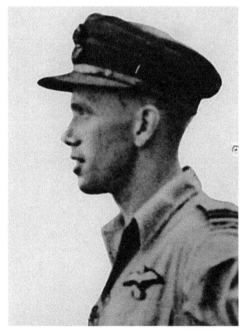

Flight Lieutenant David Lord VC
Flight Lieutenant David Lord VC flew from Down Ampney on Operation Market Garden to Arnhem in September 1944. His Dakota was hit by enemy fire over Arnhem, but despite the aircraft being on fire, he made two of his three equipment drops. On the third drop the aircraft crashed, killing Lord and all but one of his crew. For his courage, he was posthumously awarded the VC; he was the only member of Transport Command to receive this award.

Flight Lieutenant Jimmy Edwards DFC

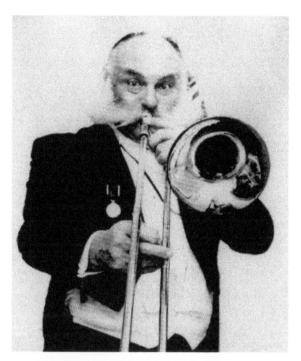

Flight Lieutenant Jimmy Edwards DFC, who later became a famous comedian and actor, flew in the same operation from Down Ampney. His aircraft crashed in Holland after being attacked by enemy fighters. He stayed in the aircraft because some of the crew were trapped and unable to bail out and made a successful crash landing, despite the fact that the windshield was covered in oil, by standing on his pilot's seat and looking out of the observation dome. He received severe burns to his face and arm, but was awarded the DFC for his bravery.

Sergeant Fred Petrie MM of the Royal Engineers

Sergeant Fred Petrie MM of the Royal Engineers was among many of Cirencester's citizens who went to war. He received the Military Medal and mentions in despatches for his acts of bravery, including his rescue of an officer under heavy enemy fire during bridging operations over the River Seine. He was also the first to volunteer to take a rescue craft across the Rhine at Arnhem to save the retreating British troops, many of whom had set out from bases around his hometown only days before.

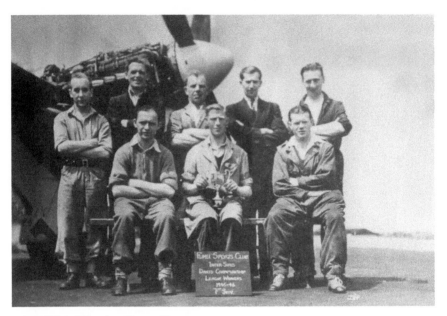

RAF Kemble's Winning Darts Team
The civilian workers at RAF Kemble still found time for social activities, despite being heavily involved in the construction and modification of aircraft such as the Typhoon for the final phases of the war. This team won the Inter-Sites Darts Championship League in 1945/46. RAF Kemble's social committee also did sterling work in the community. Their craftsmen made roundabouts and other fairground-type amusements that were used to raise funds for good causes long after the war.

The 192nd Hospital Mess Hall Prepared for Christmas, 1944
Despite all, everyone tried to make Christmas 1944 as pleasant as possible. This was the mess hall at the 192nd Hospital, prepared for Christmas dinner. The children of the town visited the US hospital wards singing carols and the patients at the 192nd hospital were amazed to receive a visit from Mr White Christmas, Bob Hope, and his troupe. Earlier in the year, the Bingham Hall Club had had visits from film and singing star Irene Manning, vaudeville artist Sam Lavine, Bebe Daniels, and Ben Lyon and, on a slightly more serious note, Yehudi Menuhin.

Father Christmas Visiting the Children of Gloucester Street and the Bowling Green
A US Army sergeant kindly stood in for Father Christmas at a children's party given at the Nelson Inn, Gloucester Street, where the Americans had a postal depot. Other local children were also invited to a party at the 188th Hospital.

Home Guard Stand Down Parade in the Abbey Grounds
The Home Guard had their stand down parade in the Abbey Grounds on 9 December 1944. At this time most of the ARP services were relieved of their weekly parades and practices and blackout had become dim-out. The war continued abroad with many of the airborne troops from the local bases taking part in Operation Varsity, when the Allies crossed the Rhine into Germany. Sadly the casualty lists of local men and women grew ever longer, but the end was in sight.

Cirencester Parish Church Tower

Following the German surrender, Prime Minister Winston Churchill declared 8 May 1945 to be Victory in Europe (VE) Day. In Cirencester Parish Church, like those of towns and villages, bells pealed out in celebration. Cirencester bells had been silent throughout the war except for the celebration of the victory at El Alamein and the false alarm when a piece of a barrage balloon was mistaken for an enemy parachutist.

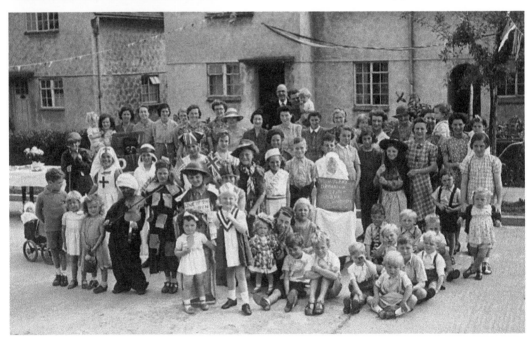

Victory Party at Springfield Road

A victory party at Springfield Road and some of the children wore fancy dress to celebrate. A shortage of time to prepare civic celebrations meant that local communities took it upon themselves to arrange parties and bonfires, despite official disapproval of wasting salvage. Eventually there was dancing in Cirencester Market Place, with Frank Smith providing the music via his ubiquitous public address system. All the local service bands were busy celebrating in their own camps.

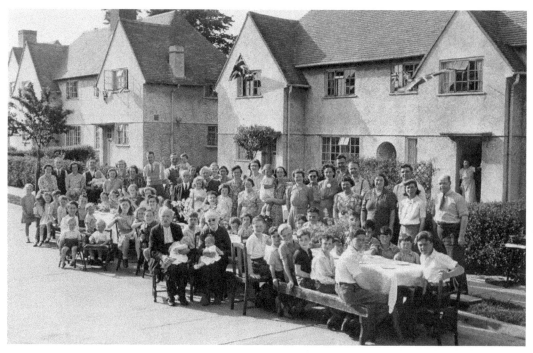

Victory Party at Apsley Road
The residents of Apsley Road held a street party to celebrate the end of the war and many of the houses are proudly displaying the Union Jack.

Victory Parade and Thanksgiving Service, Sunday 20 May

On Sunday 20 May 1945, there was a victory parade through the Market Place and a Thanksgiving Service was held in Cirencester Parish Church. Over 700 military and civilian service personnel took part. Lieutenant Thomas Johnson of the US 15th Hospital Center led the US representatives past the large water tank in front of the parish church with the British representatives at attention. The National Savings indicator on the lamp column showed that, by VE Day, local savers had saved £3,915,602. According to family records, the author witnessed this parade and had jelly for tea – and of course it rained!

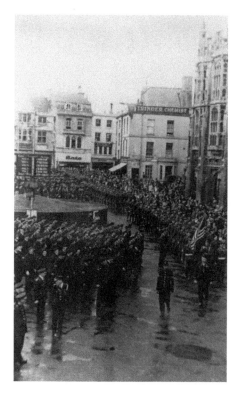

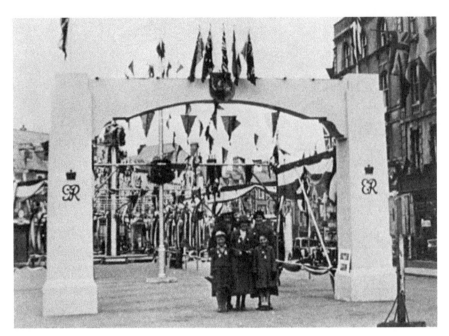

The VJ Day Decorations in Cirencester Market Place First Used for the Coronation in 1937

The war ended on 14 August 1945 with the surrender of the Japanese. In celebration the Cirencester UDC reused the main features of the coronation decorations from 1937 in the Market Place. During the day, the town band had played on the bandstand erected on the base of one of the recently removed water tanks. In addition to Frank Smith's apparatus, an RAF band was on hand for dancing in the evening following a procession around the town, which had included the Victory Rag Time Band.

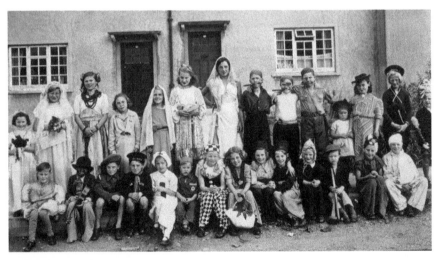

The Sperringate VJ Party

To celebrate victory in Japan and the end of the war, street parties were again the order of the day throughout every community in the Cotswolds and no doubt on every one of the thirty-four military establishments within 12 miles of Cirencester. The children of Sperringate managed to find fancy dress for their party.

Kenley Lass with her Dickin Medal

One unusual Cirencester war hero was Kenley Lass, a pigeon bred by Don Cole, the landlord of the Bull Inn in Dyer Street. She served with the National Pigeon Service from RAF Kenley. In October 1940, she was parachuted into France with a secret agent who collected information then sent her back with the messages to Kenley some 300 miles away, a journey she made in one day. In 1945, Kenley Lass was awarded the Dickin Medal – the animal VC for this operation, which was the first of its kind for a pigeon – and for another operation completed in February 1941.

The POW Model Church

At the end of the war, Siddington Hall became a prisoner-of-war camp with over 200 Germans housed in the main building and Nissen huts in the grounds. The prisoners were taken out to work on local farms and other projects, such as preparing the first roads for the Beeches housing estate. In their spare time, they took to handicrafts. One group made this model church, which was later given to Our Lady's Convent School at Chesterton House. Others restored the windows of the Friends' Meeting House.

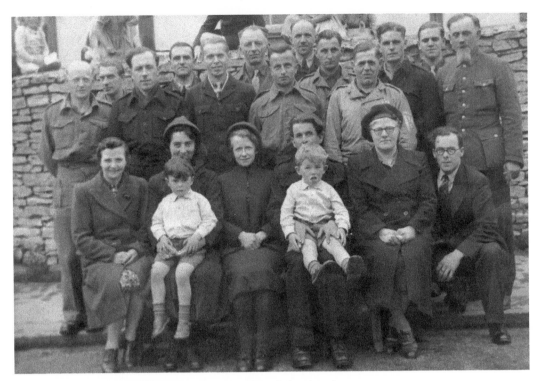

A Group of German POWs Who Attended The Salvation Army

When hostilities ceased, the prisoners of war were allowed out into the community and kept links with local families. Some attended The Salvation Army meetings in Cirencester until their repatriation in March 1948. The author is seated on his mother's knee on the front row. Second from the right on the back row is Karl-Heinz Geilen, who returned to his home city of Hamburg to work in the Lutheran church, working first in a Lutheran children's home and then becoming *schiffermissioner* (seaman's missioner) to the barge people of Europe, many of whom were from behind the Iron Curtain.

Karl Heinz Geilen in 1974

Karl Heinz Geilen on the deck of his *flussschifferkirche* (floating church) in Hamburg's dockland in 1974. The only time the church, which is a converted barge, has been moved, other than for maintenance, was when Hitler commandeered it for his aborted invasion of Britain, Operation Sea Lion.

Cadet Janina Pladek of The Salvation Army
Janina Pladek, whose story is recounted in the book *Caught in the Crossfire*, fled home in Poland with her family, fleeing first from the Germans and then the Russians. She came as a refugee to the displaced persons' camp, which had been set up in the vacated 111th US Hospital at Daglingworth. She joined The Salvation Army in Cirencester and, being a linguist, was able to act as interpreter for the German prisoners of war. She trained as a Salvation Army Officer and served with her husband, Douglas, in Scotland and Zululand.

Mrs Major Janina Neale, *née* Pladek at Work in Africa
Mrs Major Janina Neale, *née* Pladek at work in Africa. Janina and Douglas worked for many years among the Zulus and even in retirement they continued to work on a voluntary basis, providing essential goods to their former 'parishioners'. A story that began in Poland passed through Cirencester and went on to Africa.

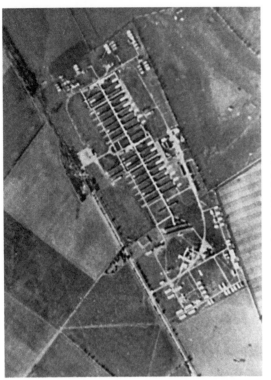

Aerial View of the 111th US Hospital

This aerial view shows the 111th US Hospital, which was later used as a displaced persons' camp, then became a permanent home for the exiled Polish community, as did the 186th Hospital at Fairford. It was used until the 1960s, by which time many of the families had moved out into the local community. They, like the many newcomers from all around Britain, brought new attitudes and ideas and broke down some of the old class and economic barriers and ideas, which contributed to a mood of optimism, even in the austerity of the immediate post-war period. The Poles also brought continental football to Cirencester!

Victory Celebrations Programme

It was a year after the war before the town felt ready to celebrate victory properly with a day of victory celebrations on Saturday 8 June 1946. The Union Jack was hoisted on the Municipal Offices to herald the day, followed by a peal of bells from the parish church where a Thanksgiving United Service was held. This was followed by the start of a cycle race from Cirencester to Fairford and back. There was cricket in the park between Cirencester 1st IX and the Dowty Engineering factory from Cheltenham, and entertainment in the Market Place by Cirencester Silver Band and a Punch and Judy Show. At 12.45 p.m., the three separate processions for the Victory parade set out from Abbey Way, Kingsmead and Bathurst Road to meet in the Market Place, where a Typhoon aircraft from RAF Kemble was on display. The procession then moved on to the grammar school field in Victoria Road for the judging and programme of sports events that lasted for six hours. The day ended with dancing in the Market Place and Corn Hall then a fireworks display.

CIRENCESTER·
URBAN DISTRICT COUNCIL.

WORLD WAR - 1939-1945.

Victory
Celebrations

Saturday, 8th June, 1946.

PRICE 6d.

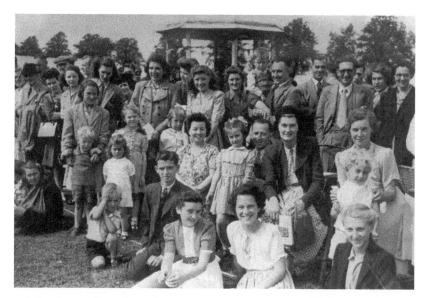

Some of the Sports Day Crowd
Hundreds of people gathered for victory celebrations. Many of the men and women of the town had returned home from the forces or other war work to family life, which had been disrupted for so long. Others were still away in the Far East or the former territory of the Third Reich and there were those who would never return, whose relatives would have found it hard to celebrate that day.

Vintage Military Vehicles Visiting the Memorial Hospital Air-Raid Shelter
The Second World War has left little physical evidence in Cirencester, except the odd building or loophole. The Living Memory Historical Association uses the Memorial Hospital air-raid shelter, seen here during a visit from vintage military vehicles, as an exhibition venue for displaying wartime artefacts. American war planes still fly over the rooftops from RAF Fairford and the military retain South Cerney Camp as an army base, with the occasional parachutist dropping in for training or raising funds for charity. Kemble survives thanks to private enterprise but, sadly, less-informed newcomers find the aerial activity irksome, not appreciating past sacrifices.

The Down Ampney and Blake Hill Memorials
There are reminders of the dedication and bravery of those who risked and gave all during the war on the memorials in local towns and villages. These memorials are situated at Down Ampney and Blake Hill, where today we find farming and light industry instead of military action.

Opposite: **The Cirencester Parish Church War Memorial**
The names on Cirencester's recently restored war memorial outside the parish church are a stark reminder that the Second World War, like the First World War, was no respecter of persons. Lord Apsley died when his aircraft crashed in the Mediterranean. He had planned to return home on leave to meet up with his family for Christmas 1942, and his young sons risked travelling back from Canada through U-boat-infested waters to be there, but he did not make it home. His name stands alongside Alfred Scrivens, who was killed on D-Day, Richard Allport, who has no known grave, and sixty-six other servicemen. The memorial does not record the names of those who lived on, maimed in body and mind, or the names of civilians who died.

Cirencester's population increased by around 40 per cent during the war and many decided to stay after 1945, making the town today very different from pre-war Cirencester. There were many social changes after the war: for example, large housing developments were built. The town lost its railways and gained ring roads; local government changed beyond recognition and many of the old institutions changed or disappeared. Others will judge how permanent the wartime changes proved to be.

Also Available from Amberley Publishing

DAVID & LINDA VINER

CIRENCESTER

THROUGH TIME

This fascinating selection of photographs traces some of the many ways in which Cirencester has changed and developed over the last century.

Paperback
180 illustrations
96 pages
9781848680432

Available from all good bookshops or to order direct
please call 01453-847-800
www.amberley-books.com